MW00996899

The Art of COMIC BOOK Inking™

E. RUDE

DARK HORSE COMICS®

The Art of

COMIC BOOK

S. RUDE

Inking™

by

GARY MARTIN

with

STEVE RUDE

featuring

TERRY AUSTIN	JOE RUBINSTEIN
BRIAN BOLLAND	P. CRAIG RUSSELL
MARK FARMER	MARK SCHULTZ
RUDY NEBRES	DAVE STEVENS
KEVIN NOWLAN	KARL STORY
JERRY ORDWAY	BILL STOUT
TOM PALMER	SCOTT WILLIAMS

ACKNOWLEDGMENTS

Thanks to Jane Holmes Martin, who did my typing and had to put up with my mutant ability to misspell every word possible. Big thanks to Lurene Haines for her sage advice and encouragement and to Mike Friedrich for his support from the very beginning. I'm grateful to Steve Mattsson for sharing his Macintosh wisdom. Thanks to everyone at Studiosaurus for their help and input: Terry Dodson, Randy Emberlin, Matt Haley, Karl Kesel, Rachel Pinnock, Ron Randall, Tom Simmons, and an extra back slap to Aaron Lopresti. (I hope this will make up for that "Captain America gig" phone-call prank, Aaron.) A special thanks to all the artists listed on the cover, without whom I never would have attempted to put together this book. My deepest appreciation to Steve Rude. Over the years, inking Steve on *Nexus* has been the hardest and most satisfying work I've done in comics. His contribution to this book cannot be overstated. Steve, thank you for taking me to "art school"! And I can't leave out *Nexus* editor Anina Bennett, who hammered my manuscript into shape and made many useful additions. I've already urged her to write a similar book about editing comics.

David Olbrich gets his own paragraph, because without Dave's representation, *The Art of Comic-Book Inking* would not have been published. His wisdom, endurance, and professionalism were a constant source of encouragement. Thanks, Dave — "you da man"!

This book is dedicated to the memory of Nestor Redondo. Nestor's art has always been an inspiration to me. When he agreed to contribute to this book, I was thrilled and honored. Unfortunately, he passed away before the book was completed. His elegant ink line and incredible drawing ability were equaled only by his strength of character. Do yourself a favor and track down his work. You're in for a treat.

TABLE OF CONTENTS

FOREWORD

What is a Comic-Book Inker?

"What does an inker do? Are you responsible for the coloring? Don't you just trace over the lines? How much of the linework is done by computer?"

You would not believe how many times I've heard these questions in my 16-year, comic-book-inking career. By writing this book, I hope to demystify a very important part of the comic-book creative process. If you've purchased this book solely for the art by our spectacular roster of contributors, you'll get your money's worth. But *The Art of Comic-Book Inking* is mainly intended for:

- people who want to become inkers
- working inkers who haven't had professional training
- pencillers who want their work to be more inker-friendly
- the majority of editors working in comics today

Inkers are ultimately responsible for the stylistic look of most comic-book art, including that uniquely American genre: superhero comics.

Inking is important largely because pencil lines are much harder to reproduce than bold, black, line art. It's also more difficult to create a variety of line weights and textures with a pencil than with a brush or crow-quill pen.

Of course, printing and imaging technologies are more sophisticated now than during the Golden Age of comics (1930s-1940s), so it's possible to reproduce pencil art more accurately than ever before. But the inked line is still easiest to reproduce and — in an ironically high-tech twist — generally most compatible with computer coloring. The contour ink line continues to be essential to the art form of comics.

Below are the comic-book inker's primary job responsibilities as I see them. These goals are the foundation of my inking approach.

1. The inker's main purpose is to translate the penciller's graphite pencil lines into reproducible, black, ink lines.

This goal seems so basic and self-evident that it's sometimes overlooked. Nevertheless, it should be the inker's number-one priority.

2. The inker must honor the penciller's original intent while adjusting any obvious mistakes.

Staying true to the integrity of the pencil work is very important. However, sometimes even the most godlike pencil artists make mistakes. It's your responsibility to identify these mistakes and fix them when possible. The inked line is what's reproduced in the finished comic book since pencil lines are erased after inking. So the excuse that a mistake was "in the pencils" just doesn't cut the mustard!

3. The inker determines the look of the finished art.

Inking involves many decisions about line weights, contour styles, solid blacks, textures, and other artistic concerns. These combined decisions result in what most people visualize when they think of comic-book art — i.e., inked pages. Line weights (see Chapter III) are especially important since they factor into almost every aspect of drawing. The use of varying line weights is a defining element of comic-book inking, particularly in "mainstream" American comics.

For those of you considering a career as a comics inker, be forewarned that inkers are often underappreciated and overlooked when the art in a comic is being lauded. Let's be realistic: the star of the comic-book creative team is the penciller. Most people buy the comic to see his or her art. Remember, job responsibility number

two is to make the penciller look good. The bet-
ter you do that job, the more your penciller will
appreciate you — and the more chance you'll
have of consistently working on good projects
with talented pencil artists.

For pencillers reading this book to get some
inking insights, my main comment is that *inking
is not tracing*. If you expect the inks to be exactly
like the pencils, you should just use a harder lead
and dig grooves in the paper when you draw, then
pour ink on the page and wipe off the excess.

I worked with a penciller for a while who had
(and still has) a tendency to get facial proportions
kind of squirrelly — the eyes out of place, or the
nose out of line with the mouth. I was fixing them
in the inks, and he told me not to. He wanted me
to ink it exactly the way he'd drawn it. When I
told him his proportions were wrong, he said he
didn't care. "That's part of my charm!" was his
reply. Unfortunately, his ego interfered with the
art. There's a difference between idiosyncratic art
and sloppy draftsmanship, and inkers as well as
pencillers should be able to tell them apart.

Inkers can be thought of as another pair of
eyes. They can help the art read more clearly by
fixing problems that you may not have seen.
They are part of the art team and will have their
own creative statement to make. As long as they
stay true to the pencils, you should appreciate
their contribution.

The other group of comic-book professionals I
hope will read this book are editors. Since editors
assemble art teams, they should understand the
value of a good inker. The right combination can
yield awesome results, and the wise editor has
the opportunity to orchestrate this magic. The
wrong stylistic combination, on the other hand,
can be disastrous even if both penciller and
inker are brilliant.

The inker should be part of the creative
process from the very beginning. Ideally, an inker
should be selected before the penciller has started

drawing since the inking helps determine the art's
overall style. Editors should also listen to their
pencillers when choosing inkers. I'm amazed by
how often editors totally disregard pencillers'
wish lists, instead picking inkers (apparently at
random) from their usual "stable." Good
pencillers know what suits their own art the best
— and good editors know that if they hook up
two artists who want to work together, that team is
likely to be more motivated and will produce
better work.

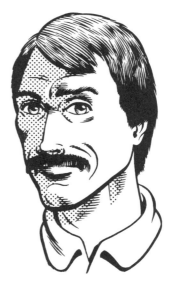

Although I wrote the how-to section of this
book, that doesn't mean I'm saying that mine is
the only way to ink. It's one man's approach.
Art, by its nature, is intuitive. That's why I
included contributions from top artists in the
comics industry — to help give an idea of how
the same basic techniques can be applied to a
wide variety of styles.

If you disagree with my opinions, I encourage
you to write to me care of Dark Horse Comics.
But I warn you, I'll hammer you into submission
with my logic. The guys at Studiosaurus don't call
me "the Spock of inking" for nothing!

—Gary Martin, Portland, OR

GLOSSARY

Below is a list of terms commonly used in describing comic-book art. Because these words can mean different things to different people, I'm providing my own definitions — so at least you'll know what *I* mean when I use them.

Contour line: The outline of a figure or object; also known as a "holding line."

Cursive line: A flowing, elegant, ink line that is thin on one end, thicker in the middle, then thin again on the other end (see figs. 4, 5, & 13).

Dead-weight line: A line with a consistent width, not varying in thickness (see figs. 1 & 2).

Feathering: A series of lines that are thin on one end and thicker at the other end (see figs. 6-12).

Filling in blacks: Inking in the solid black areas on a page where indicated by the penciller; not to be confused with spotting blacks.

Finishes: These are the spotting of blacks, the adding of details, textures, and feathering to an incomplete pencilled page such as a layout or breakdown.

Force lines: Long, feather, or cursive lines that emphasize an action or event by surrounding and pointing toward it (see fig. 12).

Gritty: An overused term — especially by editors — that means . . . well, I don't know what it means!

Gutters: The white space between panels and around the edges of the page.

Line weight: The thickness of an ink line.

Loose: An inking style that is less controlled and more spontaneous and free-flowing, or a pencilling style that is vague and sketchy.

Negative space: The white space on an inked page.

Slick: A controlled inking style that is smooth and precise; Joe Sinnott's work epitomizes this term.

Spotting blacks: This means deciding where to place solid blacks on an incomplete pencilled page then filling them in.

Terse line: A contour line that's thin on one end and thicker at the opposite end (see figs. 29 & 56C).

Tight: A pencilling style that is clear and precise, making the inker's job of interpretation easier.

Volume: The appearance of three-dimensionality in a two-dimensional drawing.

The Art of

COMIC BOOK

Inking

S. RUDE

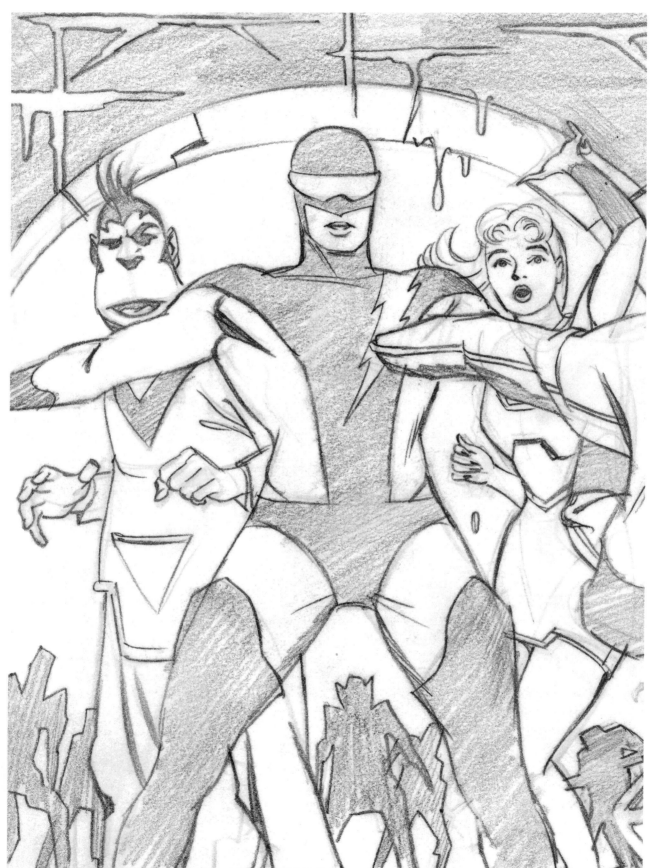

I

BEFORE YOU START

Learn to Draw!

A prerequisite to becoming a comic-book inker is *knowing how to draw*. The process of inking a comic-book page includes making dozens of drawing decisions as you translate the pencils into inks. You must also be able to identify and fix mistakes when you come across them.

Above all, *do not make comic books your only source of art training!* Superhero anatomy in particular is exaggerated and stylized. You need to learn how to draw real people before you experiment with developing your own style, whether exaggerated or naturalistic.

I strongly recommend taking some life-drawing classes from an art school, local studio, or community college. Drawing from a live model is the best way to learn about the human figure. If this is not an option for you, there are many fine anatomy books designed for artists as well as countless sources of visual information on art history and illustration techniques.

Get out and draw the world around you, too. Public parks, cafés, zoos — anywhere you can hang around long enough to fill a few sketch-book pages.

Study the Real Thing

Of course, you can still learn from comic-book art in addition to other sources. The best way to study inked art up close is to collect original pages. The original can give you much more information than a page printed in a comic book. This can be an expensive form of education, but you can cut costs by buying "dialogue pages" without big action or splash panels. You can usually pick up such pages from professional artists at local comics conventions, or sometimes from art dealers.

After you've obtained some good-quality, original art, you can practice by putting tracing paper over the page and trying to ink on top of the existing lines. This is good control practice, and it helps you get into the inker's head to figure out why he or she made certain inking decisions.

Do Your Math

Generally speaking, artists and mathematics don't mix very well. But like it or not, before you launch into a career as a comic-book inker, you need to think about how much money you'll make. A good starting rate for inking is $100 per page. If you can only ink one page a day and are fortunate enough to get a regular gig of 22 pages a month (plus covers), that adds up to about $28,000 a year. Subtract one-third for the I.R.S. because you will now be self-employed and paying quarterly tax estimates. If you're single and still living at home, this isn't bad. But if you have a family and a mortgage, you should now qualify for food stamps! At the other end of the scale, if you've been inking for a while and can do two pages a day at a top rate of $150 per page, that's about $80,000 a year. Only the best and the fastest can do this.

A word about royalties: Only a select few creators are lucky enough to receive royalty payments on a regular basis; the days of the giant royalty check are long gone. This is not income you can count on.

II
GETTING STARTED

Tools of the Trade

You'll need the right equipment if you want to ink professionally. Following is my list of useful tools and supplies. As you experiment, you may find that you prefer another brand of brush or ink. Use whatever works best for you.

Drawing table: An adjustable surface angle is a must.

Good light source: A full-spectrum, Chromalux light bulb helps reduce eyestrain, and a swing-arm, adjustable lamp puts the light where you need it.

Inking brushes: Winsor & Newton series 7 or Raphael 8404, both in numbers 2 or 3.

Crow-quill pens: Hunt 102 is the industry standard; use Hunt 107 for a flatter line, Hunt 512 for a bolder line. Rotring pens combine crow-quill tips with ink cartridges like those in technical pens.

India (black) ink: Higgins, FW, Black Magic, or Pelikan waterproof drawing ink.

Erasers: Higgins, Magic Rub, or Staedtler Puraplast.

Technical pens: Staedtler disposable or Rotring Rapidoliner, in sizes 0.3, 0.35, and 0.7 mm.

White ink: FW white and Pro White (opaque watercolors) work on most black inks; standard white-outs like Liquid Paper do not.

Nonphoto-blue pencil: Also called "nonre-pro blue." Look for one that won't show up on photocopies.

Black crayon or grease pencil: Used for a rough or "toothy" effect.

Old toothbrush: For splatter effects.

Old sponge: Good for adding texture.

Tracing paper: Handy for practice inks and inking on overlay. Some types repel ink, so try out different brands.

Masking film: Also known as frisket; for masking off art when you apply splatter or other effects. You can buy this ready-made or make

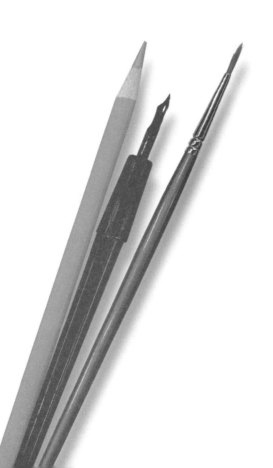

your own by very lightly spraying repositionable glue on one side of a sheet of tracing paper. (Be extra careful with the do-it-yourself version!)

Zip-a-Tone: A brand name for shading film, often used as a generic term; other brands include Format and Chartpak. Shading film comes in a wide variety of dot patterns and textures printed on a transparent sheet with adhesive on the back side.

Ruler: The see-through kind with a beveled edge is best; a T-square can also come in handy.

Circle and ellipse templates: As many sizes and shapes as you can get your hands on, to aid in inking everything from the moon to a frying pan.

French curves: Two or three different shapes.

Compass: Get one that'll hold a technical pen.

X-acto knife: You'll need this for cutting things like masking film and Zip-a-Tone.

White artist's tape: For taping together double-page spreads; also for covering up the occasional, large, ink splotch, especially in gutters.

Lap board: Good for erasing pages and X-acto cutting.

Draftsman's brush: Brushing eraser crumbs off your pages is better than blowing them off. (Spitting on pages is bad!)

Container of water: Keep one close at hand for rinsing out brushes and diluting ink.

Paper towels: Use them to wipe off brushes, blot sponges, or in case of emergency.

Beverage: Your choice. Lime-Aid out of a peanut-butter jar is a Terry Austin fave!

Brushes vs. Pens

What are the advantages of inking with a brush over inking with a crow-quill pen? Versatility, for one: A brush is capable of both a finer line and a much bolder line than a pen. It can also hold more ink, so you don't need to dip into the inkwell as often.

Despite that, pen lines take longer to dry than brush lines because the crow-quill pen lays down a thicker bead of ink on the paper. It's easy to forget where these wet lines are and plop your hand right down on top of them, thus smearing your page all to heck! With a brush, you can ink an entire panel in one go, then move on to the next one. With a pen, you have to ink part of the panel, then work on different areas of the page while you wait for your lines to dry.

The main advantages of the crow-quill pen are that it takes less time to learn how to use and you can ink faster with it. (Remember, speed = $$$!) Also, if you like a harder-looking line, this is the instrument for you.

It takes longer to learn how to control a brush — much longer. It took me about three years of inking professionally before my brush started doing what I wanted it to. Inking comic books with a brush is an old tradition, but I fear it's a dying art. The satisfaction of mastering this craft is well worth the time and effort involved.

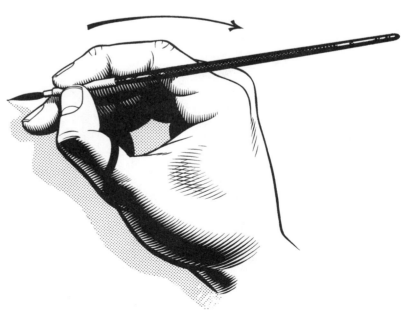

figure A

Inking With a Brush

First, saturate your brush with ink. Wipe it off two or three times on the ink-bottle rim, then roll it on a scrap of paper to get a fine point. Grasp it between your thumb and forefinger and rest it on your middle finger (see fig. A). Plant the side of your hand (at the wrist) on the paper; this is the pivot point. Now rest your middle finger down on the paper. Do not move the brush or your fingers when inking — only move your wrist at the pivot point with the brush in this locked position. Ink lines from left to right in a horizontal direction, using the natural curve of your wrist. (This is for a right-handed person; you lefties do the opposite.) Just rotate the page as you work to keep the lines horizontal. Some inkers like to go vertically by dragging their hand down the page when they ink a line. Again, experiment until you find the working method most comfortable for you.

The secret to controlling your brush is controlling the ink flow. Bold lines need more ink in the brush and more pressure on the brush stroke. Thin lines and detail work take very little ink in the brush and a very light touch on the brush stroke. Don't do detail work with a brush full of ink.

For detail work on a face (e.g., a nostril), first outline the shape, then fill it in. Don't try to do this with one stroke; you risk losing the shape the penciller has put down, thus changing the features.

Do not use technical pens or felt-tip markers when inking figures. Tech pens produce a flat, dead line that will not add variety or life to your figure work. Markers contain a different kind of ink that will fade over time, making your originals green and worthless.

For a more controlled technique when feathering (see Chapter VI), use slow, even strokes and ink into the blacks, thin to thick. For a looser approach, increase your hand speed and ink out of the blacks when feathering, starting at the thick end and moving toward the thin end of each feather line.

All the lines in figures 1-13 were inked with a Winsor & Newton series 7, number 2 brush and reproduced at original size. These are some of the types of lines you will be inking in comics, whether with a pen or a brush. Practice them over and over again until you're sick of doing them — then do some more! Look for consistency in line quality and spacing. When you've started getting a handle on these line techniques, you'll be ready to ink figures.

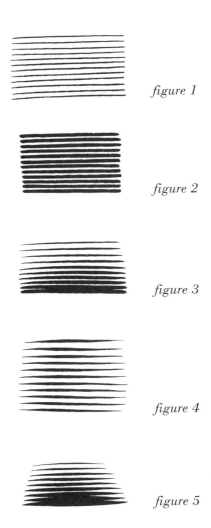

figure 1

figure 2

figure 3

figure 4

figure 5

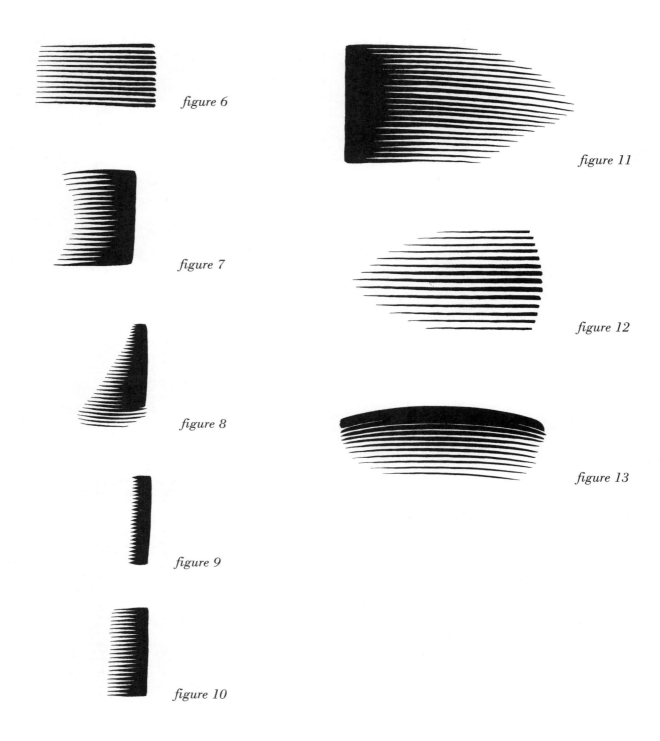

figure 6

figure 7

figure 8

figure 9

figure 10

figure 11

figure 12

figure 13

III
LINE WEIGHTS

Establishing the Light Source

The first thing you need to do when inking a comic-book panel is determine which direction the light is coming from. This is most important because it's the cornerstone of all your subsequent line-weight decisions. The penciller's placement of shadows will eliminate some of your guesswork. But (and this is a big "but") sometimes there are no clues as to the direction of the light. In such cases, our hero — the inker — must step in to save the day!

The easiest way to indicate the light source is simply to use a heavy line weight on the dark side of an object and a thinner line weight on its light side. This works with almost everything: a leg, arm, or body; a lamppost or telephone pole; a tree, shrubbery, or even the castle Anthrax. The exceptions are objects that are not solid, such as clouds, fire, or smoke.

This pencil drawing of a post sticking in the ground (fig. 14) is flat and indistinct. By adding a heavy line weight and a shadow, not only have we planted the post firmly into the ground, we've also given it mass and form. The same technique can be used with figures. Notice how the little man in figure 14 looks more three-dimensional when he's inked with varying line weights and a shadow.

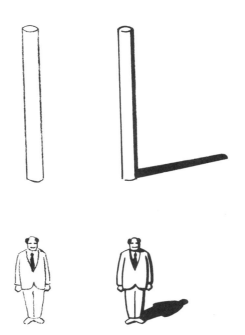

figure 14

Now look at the arm in figure 15. Even though this arm is inked, it still looks flat and weak. In figures 16-18, the arrows show which direction light is coming from. Adding heavy line weights to the dark side of each arm suggests weight and volume.

Varying your line weights works like a charm when there's only one light source in a panel. But when the penciller has added a secondary light source to a figure, your line-weight decisions become more complicated. I almost always base my line weights on the primary light source, then use the secondary light source to help determine how to handle highlights and other such details.

For the most part, light sources should stay consistent from panel to panel within each scene. Shadows on figures and objects shouldn't move around randomly. Also watch out for lighting schemes that may conflict with common sense and/or information in the story — for example, shadows pointing west when characters are riding toward an off-panel sunset. Keep in mind, though, that comic-book art often uses "inconsistent" lighting for dramatic effect, and you don't want to undercut the drama just for the sake of establishing "realistic" light sources. If you do find lighting inconsistencies, always consult with your editor or penciller before making significant changes to the pencil art.

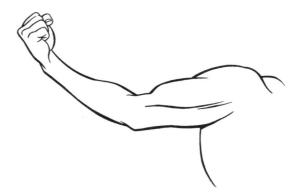

figure 15

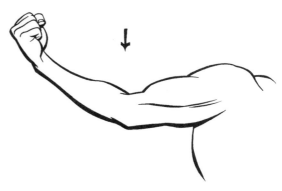

figure 16

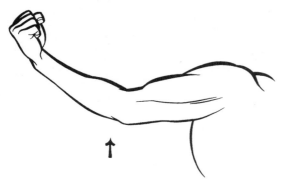

figure 18

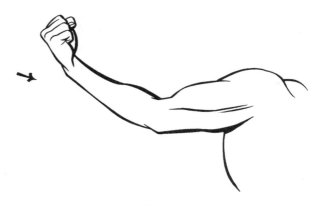

figure 17

Inking Faces

The importance of getting the faces right when inking a comic book cannot be overemphasized. Facial expressions communicate most of the emotional drama in a story. Besides, comic-book readers may miss some of the art details on a page, but they always look at faces!

One of the things I enjoy most about being an inker is working with excellent pencil artists like Steve Rude. Look at the pencilled heads (fig. B, fig. C) that Steve has provided. They're very well drawn, but with the techniques we learned in Chapter II, we can add mass, form, and volume.

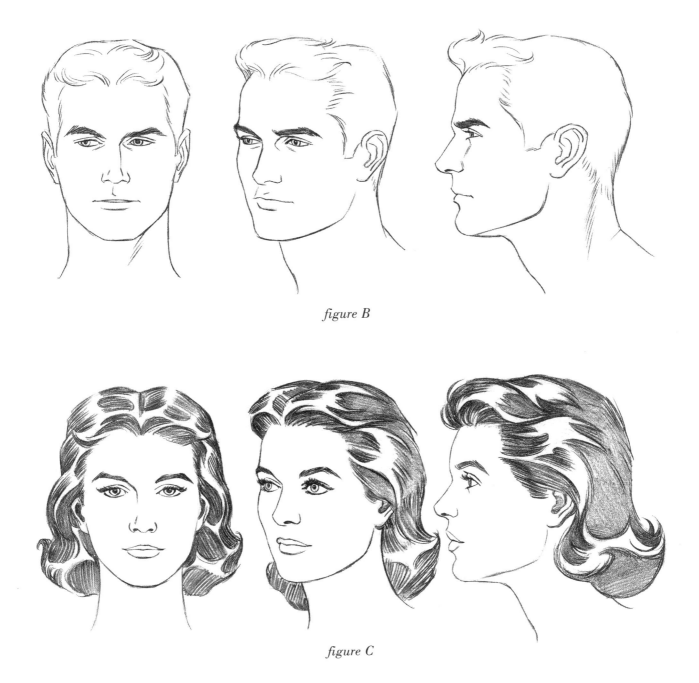

figure B

figure C

In figures 19-21, we decide that the light is coming from above, which is pretty standard daytime lighting in comics. We then add heavier line weights accordingly: the underside of the top eyelid, under the nose, under the top lip, under the bottom lip, and under the jaw line. These are the natural places where shadows fall on a face lit from above. We can't add shading in these places without changing the pencil drawing, but we can suggest shadows by using heavy line weights.

In the three-quarter angle (fig. 20), we must modify our approach since some of the face's profile is exposed: the forehead, eye socket,

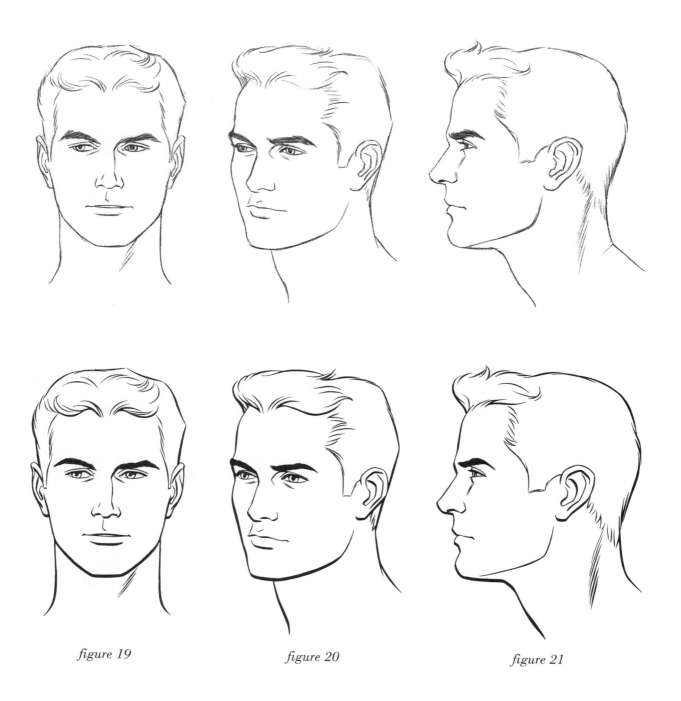

<div align="center">

figure 19 *figure 20* *figure 21*

</div>

cheekbone, and jaw line. Notice how different line weights in these areas help define the face's shape and lighting in the following manner.

- Forehead: facing light source (thin line)
- Eye socket: in shadow (heavy line)
- Cheekbone: top facing light (thin line); bottom in shadow (heavy line)
- Jaw line: in deep shadow (extra-heavy line)

With a full profile (fig. 21), these line weights are even more important. Again, note where they are and how their thicknesses are *consistent*. You don't want the line under the lip to be heavier than that under the nose, for example, but you do want the line under the jaw to be the heaviest weight. Note how a detail like the ear looks more three-dimensional in the inked version, thanks to the addition of appropriate line weights.

Check out figures 22-24 to see how we can shift the light source (indicated by arrows) simply by shifting the heavy line weights to the dark side of each head. Figure 22 uses a sidelight, whereas figures 23-24 are lit from below.

Underlighting can help create a spooky atmosphere, a shocked expression, and more. For an underlit look, reverse the line weights used in the top-lit face: everything that was thin is now thick, and everything that was thick becomes thin. Don't forget details such as a thick line on the bottom eyelid and less black in the nostrils.

Compare the profile shot in figure 24 with figure 21. Notice how different the same drawing can look when line weights are reversed. We haven't changed the pencils to establish various light sources — we just suggest them with the inker's friend, line weight!

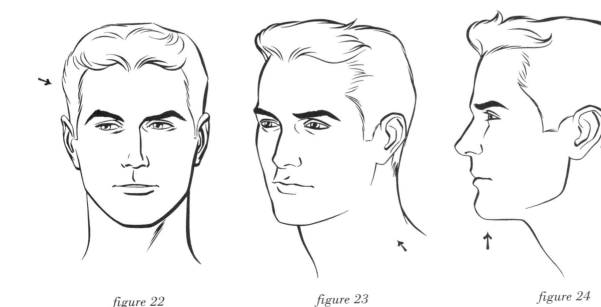

figure 22 figure 23 figure 24

When inking a female face (figs. 25-27), the same rules apply — but even more so because idealized female features are simpler than male faces. In fact, you can make faces more feminine by adding extra thickness to the upper eyelid and below the bottom lip to give the appearance of eye makeup and fuller lips. In the three-quarter angle (fig. 26), note how the cheekbone and jaw lines are rounder and less angular than those on the male face. This suggests a soft, fleshy texture. The same rules apply in the full profile (fig. 27), but the angles are rounder.

Inking Hair

While we're looking at figures 19-27, let's talk about hair. Hair happens to be one of the more difficult things to translate into black ink because its texture is wispy and solid at the same time.

Blond hair is comparatively simple. Your lines should be cursive and elegant, with weights determined by the primary light source.

Dark hair is trickier. Look at the female heads (figs. 25-27). I inked their hair with three different techniques. For figure 25, I used a dry brush (see Chapter X), which gives a very soft, almost frizzy look. In figure 26, I employed the bolder approach of massing together the blacks, producing a wetter or slicker look. And finally, in figure 27, I used feathering for a more heavily styled, "salon" look.

With dark hair, it's especially important to follow the penciller's white highlight patterns, or negative space. These patterns actually define the hair's shape, so pay as much attention to them as to the black patterns.

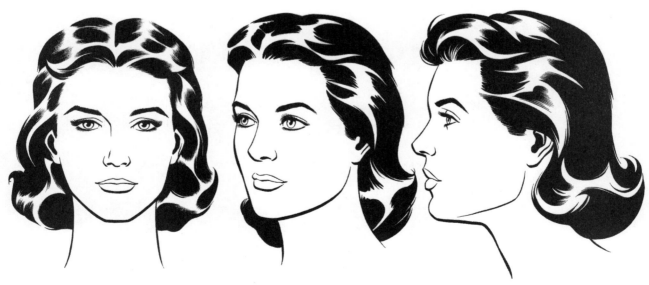

figure 25 *figure 26* *figure 27*

IV
CONTOUR LINES

The contour line plays many roles in comic-book art, including:

- "holding" the color inside figures and objects
- delineating form
- indicating texture
- acting as a design element
- creating the illusion of depth within panels

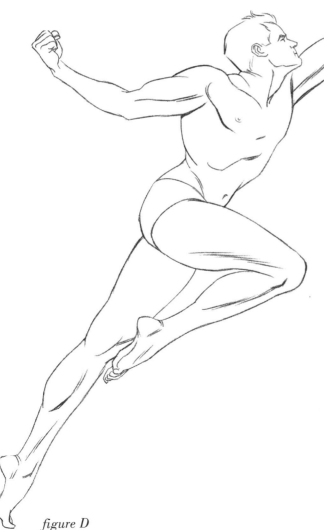

That last function is another crucial point that tends to get overlooked. You can add depth to a panel simply by outlining foreground figures with heavy contour lines, inking the middle ground with medium-weight lines, and using fine lines for backgrounds. This helps give the impression that objects in the panel are on separate planes, some closer to the reader and some further away.

There are different styles of contour lines, each of which can have a very different effect on the same pencil art. When you work with a penciller for the first time, it's important to determine which style works best for that penciller. I highly recommend that you communicate with your penciller about what kind of approach you should take. Remember, the penciller and inker are a team.

To examine a few contour styles, let's start with Steve Rude's pencilled male figure (fig. D). It's intentionally vague, offering few clues about light source or contour style.

figure D

I know from working with Steve that he prefers a cursive line, so all I need to do is decide where to beef up the line weights to indicate light direction. The results are shown in figure 28. The inked figure has mass and texture, rendered in classic, cursive style.

If you want a harder, leaner look, try a more angular or terse approach (fig. 29). Klaus Janson uses this method very well. Notice how the line weights are heaviest at the bottom part of each brush stroke, as opposed to the cursive line, in which the middle portion of the stroke is heaviest.

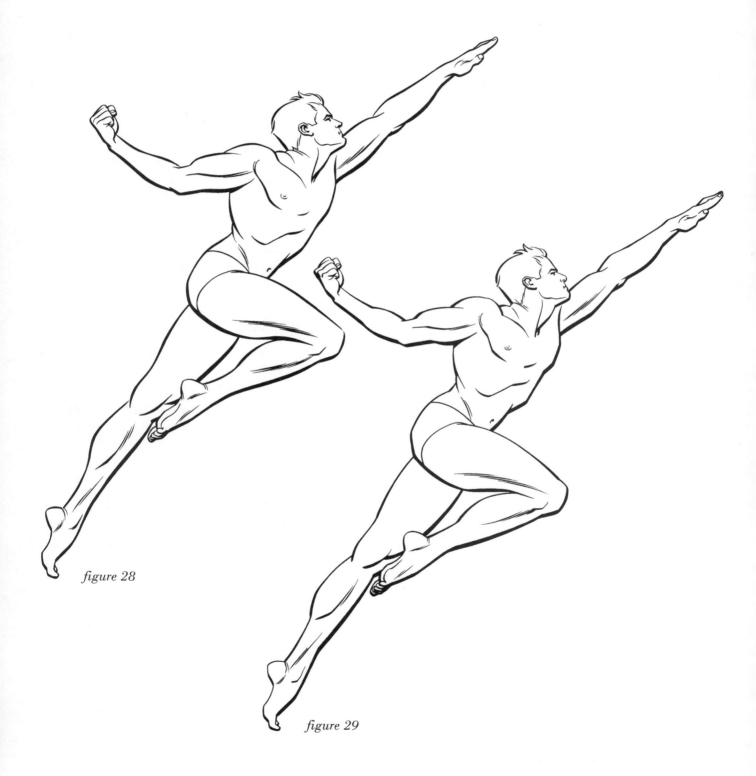

figure 28

figure 29

Steve's illustration of a woman (fig. E) has also been left vague. I usually ink female figures with a cursive line (fig. 30); it adds soft texture and feminine elegance to their forms.

When inking contours, keep working on making your line weights consistent. Your thinner lines (facing the light source) should all be more or less the same width as should your heavier lines (away from light source). As an example, in figure 30 you wouldn't want the line under her right arm to be noticeably thicker than the one under her left arm.

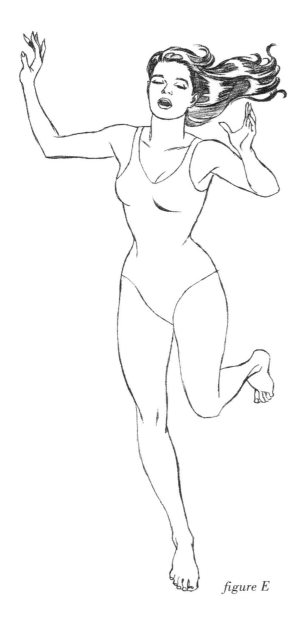

figure E

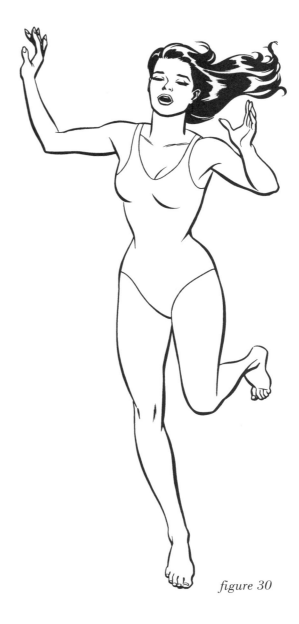

figure 30

In contrast, figure 31 is inked with a dead-weight contour line. This style is used very effectively by Dave Stevens and Adam Hughes. It creates a stylized design, juxtaposing bold contour lines with thinner, interior detail lines.

To ink a small figure (fig. 32), you must identify details that won't reproduce, then eliminate them or translate them into basic shapes. Use a very thin line for the light-source side and, of course, a thicker one on the dark side.

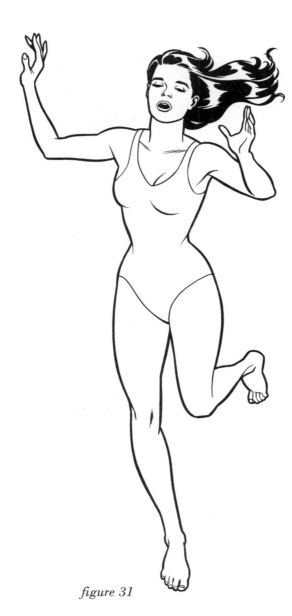

figure 31

figure 32

V
SPOTTING BLACKS

The penciller usually indicates where to place solid blacks, either with small "x" marks or by shading the areas in pencil. However, sometimes he or she may indicate too much black or not enough, making the panel look flat and/or unbalanced. The best way to solve the depth problem is to layer three values — black, gray, and white — into the foreground, middle ground, and background.

Figure 33 is a panel of outline silhouettes. Adding depth (fig. 34) is simply a matter of putting black in the first plane (foreground), gray in the second plane (middle ground), and white in the third (background). See figures 35-39 for more alternatives; notice how using different value arrangements affects the panel's design by changing the visual "weight" of each compositional element.

Make sure you don't use the same values for objects that are next to each other but on different planes (fig. 40). This effectively places both figures on the same plane, creating the illusion that the small figure is standing on the large figure's shoulder.

figure 33

figure 34

figure 35

figure 36

figure 37

figure 38

figure 39

figure 40

I realize that these guidelines are somewhat oversimplified, and you want to know how to apply them to a fully pencilled comics panel. What if you were inking a pencilled panel like the one in figure 41? This panel is over-rendered; if you squint your eyes, it looks gray and flat. To give it depth, we need to add a black value and a white value. I used the example in figure 38 as a guide. The inked panel (fig. 42) now has blacks in the foreground, whites in the middle ground, and grays in the background. It reads more clearly than the pencilled version, with relatively minor changes to the art. (Note: Adding blacks to faces can be tricky, since a misplaced shadow may alter the original construction. Check out the facial-shadow guide in Chapter IX.)

Omitting line detail when you're inking is sometimes an improvement on the pencil art — but sometimes it can interfere with a penciller's stylistic choices. As always, talk to your editor or penciller before making any drastic changes.

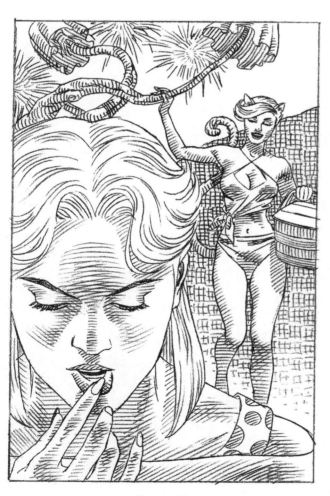

figure 41

figure 42

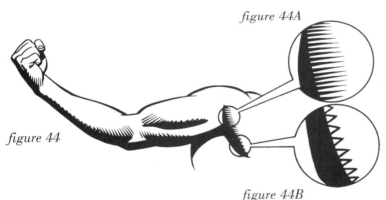

figure 43

VI
FEATHERING

Feathering has three main functions in comic-book inking:

- softening a hard, black edge
- graduating values from light to dark
- giving form and volume to objects and figures

When inking over pencilled feather lines, the ink artist is actually interpreting the pencil artist's intent. A pencil is not as good at making clear, thick-and-thin strokes as a brush or crow-quill pen. The inker must understand what effect the penciller is trying to achieve rather than just ink over the lines without knowing why they are there.

figure 44A

figure 44

figure 44B

figure 45A

figure 45

figure 45B

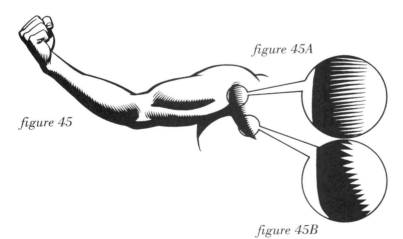

Figure 43 shows an arm, with feathering coming out of the blacks. If we ink it exactly like the pencils, the result is figure 44. We've accomplished only one out of the three purposes: softening a black edge.

In figure 45, the inked feathering serves all three functions. For a closer peek at how the lines graduate from light to dark, look at the magnified circles. In figure 44A, we see that the thick part of the feather line doesn't blend smoothly into the black edge but instead meets it at right angles. (Always keep in mind that organic shapes do *not* contain right angles!) Compare it to figure 45A, in which the negative space looks like little white needles poking into the black. This achieves function number two by giving the appearance of a more natural, gradual, light-to-dark fade. Also compare figure 44B with figure 45B.

The third function, lending volume and form, is accomplished by curving feather lines around the muscle. Look at the forearm in figure 45 and see how much more three-dimensional it looks than the version in figure 44. Rudy Nebres (see page 96) is the man to study for this technique.

figure 46

Figure 46 includes examples of horizontal feathering. Inking the pencils literally (fig. 47) is the textbook way of how *not* to do it — the lines look more like ornamental stripes than like shading. Unfortunately, this method is often used in comics today.

By following all three feathering guidelines, we get improved results (fig. 48). Again, compare the magnified circles (figs. 47A-48A). Figure 48A shows that the feathering functions better because the thick lines blend into the black, getting thinner as they graduate out from the dark areas. Scott Williams rules at this type of inking.

figure 47 *figure 47A*

figure 48 *figure 48A*

VII
CROSSHATCHING

Crosshatching is a time-honored technique of graduating light to dark by simply drawing layers of parallel, intersecting lines. It's surprising how many ink artists don't handle crosshatching well, given its long history.

On this page are examples of standard cross-hatch patterns. The pattern in figure 49 is the most common form of hatching in comics. In the top row of smaller panels next to it, we see each layer of lines separately (note their direction and length). The second row of panels shows the step-by-step effect of combining these layers. Notice how each layer further softens the black edge until the lines fade into it almost seamlessly.

The next example (fig. 50) is more complicated. This pattern produces a more random effect and softer edges. The two rows of smaller panels again demonstrate how to achieve this look with

figure 49

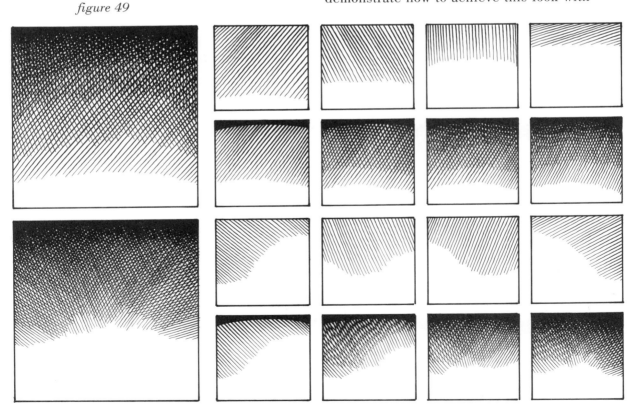

figure 50

overlapping layers of linework. Our goal is still the seamless light-to-dark fade. (See Chapter XI for a look at how this technique can be used in illustration.)

The same goes for figure 51. This pattern uses rows of shorter or broken lines that get heavier as they merge into the black, making for a particularly organic texture.

Figure 52 is an example of *bad* crosshatching. First, the lines are all the same length, so both the outer gray edge and the inner black edge are too hard. Second, the lines intersect at right angles, creating a mathematical pattern that looks monotonous and unnatural.

Figure 53 shows what happens when the lines in two layers get close to being parallel. This results in a moiré pattern that can be cool if it's the effect you're trying to achieve; however, it can also be rather jarring to the eye, and it doesn't work with every art style.

The example in figure 54 is a popular hatching technique, but it has the same problems as figure 52. In figure 55, we've solved these problems by using feathering methods from the previous chapter.

Now that you know the basics about feathering and crosshatching, I'll offer one last piece of advice: *don't overuse them.* Excessive crosshatching is not a sign of artistic skill; in fact, it's often just the opposite since overly detailed linework distracts the eye from poor construction and composition. It actually takes more skill and talent to render a figure with as few lines as possible. Alex Toth is a master of the "less is more" style.

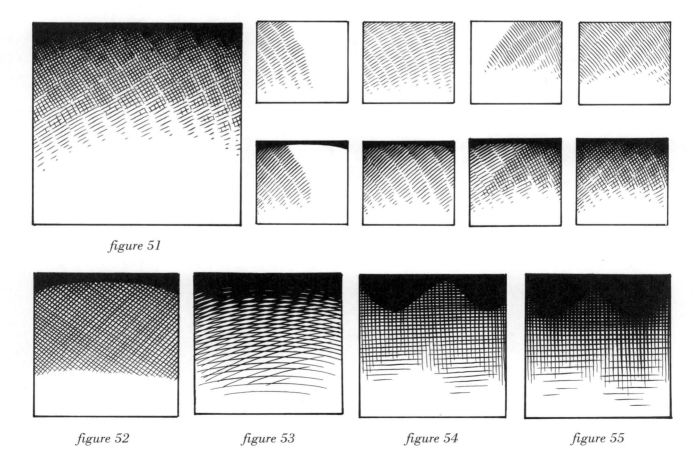

figure 51

figure 52 figure 53 figure 54 figure 55

VIII
ESTABLISHING YOUR STYLE

Every inker has his or her own style. Yours will be determined by your contour and line-weight choices, combined with your texture and feathering techniques.

figure 56

Consistent use of one approach will establish a recognizable style which generally prompts pencillers and editors to think of you when certain pencil styles need inking. Perhaps more importantly, you must be versatile enough to shift inking styles to complement a variety of pencil art. Adding versatility to your skills will put you in wider demand.

The examples in this chapter are just a few of the stylistic choices available to you. Let's start with Steve's pencilled illustration of an action guy (fig. 56), that includes spot blacks and some vaguely feathered edges. If we're not able to check with the penciller, the inking style is up to us.

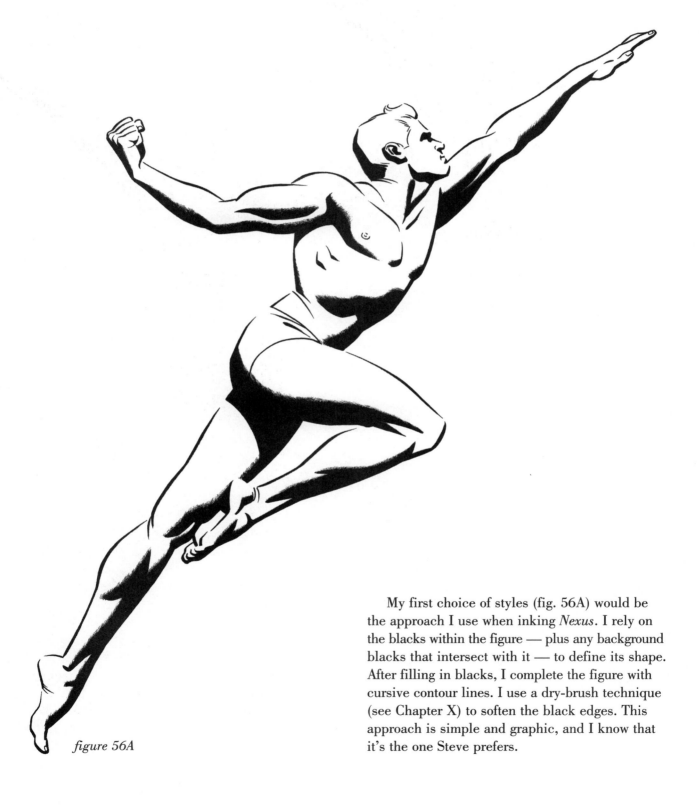

figure 56A

My first choice of styles (fig. 56A) would be the approach I use when inking *Nexus*. I rely on the blacks within the figure — plus any background blacks that intersect with it — to define its shape. After filling in blacks, I complete the figure with cursive contour lines. I use a dry-brush technique (see Chapter X) to soften the black edges. This approach is simple and graphic, and I know that it's the one Steve prefers.

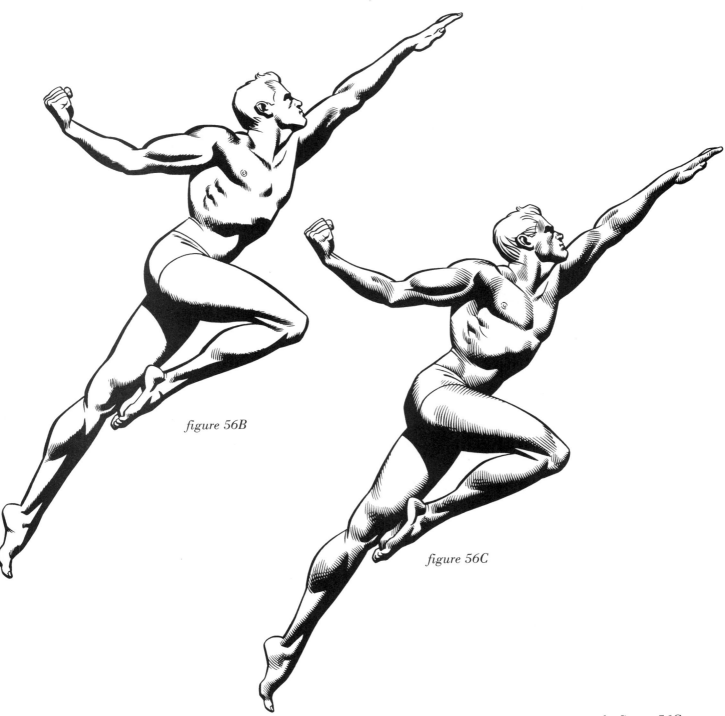

figure 56B

figure 56C

The next example (fig. 56B) is sort of a Neal Adams approach for which Tom Palmer set a standard when he inked Neal in the early '70s. The bold, terse contours are set off by delicate feather lines. In this style, the feathering lines are inked out from the black, resulting in a looser look.

Contrasting with the last approach, figure 56C employs a rendering technique that Rudy Nebres has mastered. The contour lines are not as important here because the form is defined by feathering. Notice how the tight, controlled, feather lines curve around muscle shapes, lending mass and roundness to the figure.

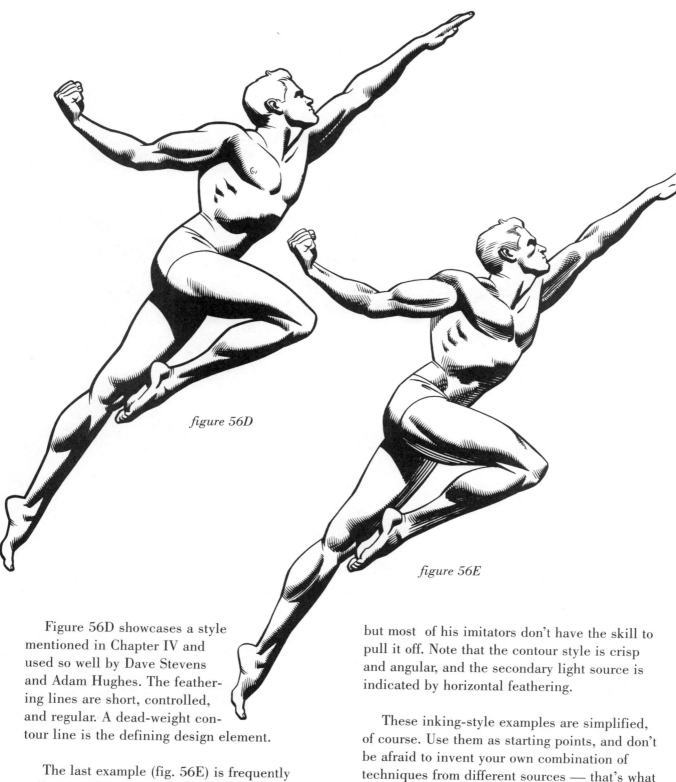

figure 56D

figure 56E

Figure 56D showcases a style mentioned in Chapter IV and used so well by Dave Stevens and Adam Hughes. The feathering lines are short, controlled, and regular. A dead-weight contour line is the defining design element.

The last example (fig. 56E) is frequently called the "Image look." Scott Williams popularized this inking style in the late 1980s,

but most of his imitators don't have the skill to pull it off. Note that the contour style is crisp and angular, and the secondary light source is indicated by horizontal feathering.

These inking-style examples are simplified, of course. Use them as starting points, and don't be afraid to invent your own combination of techniques from different sources — that's what developing your own style is all about!

IX
FACIAL-SHADOW GUIDE

Four or five years ago, I started keeping a file of light and shadow patterns on the male face. I photocopied a simple drawing of a male head 12 times on one sheet of paper then made several copies of this sheet. Whenever I come across an interesting shadow pattern on a face, from a photo

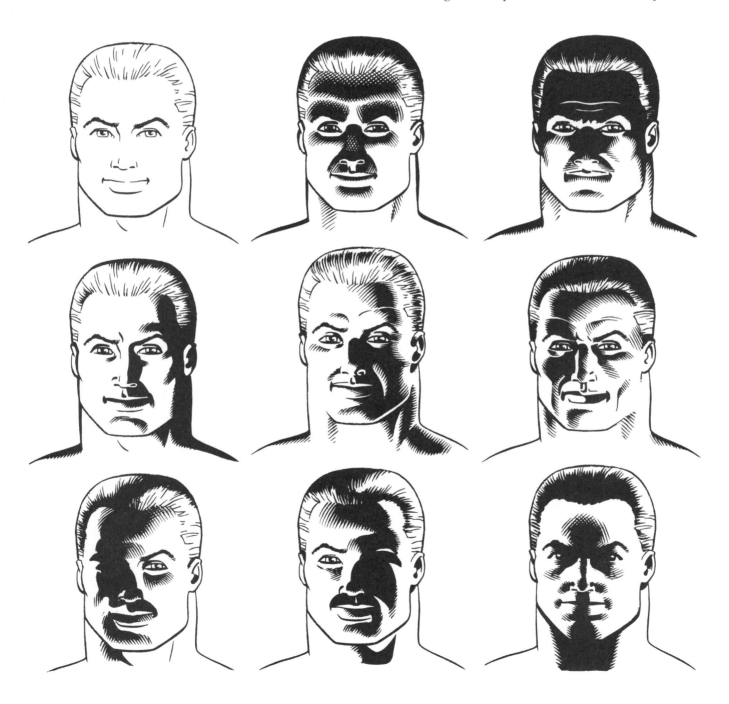

or comic book, I draw the pattern on my sheet of
heads. This guide helps me understand the
planes of the face. It's also helpful to have several
choices at my fingertips when I need reference
for adding blacks to a head.

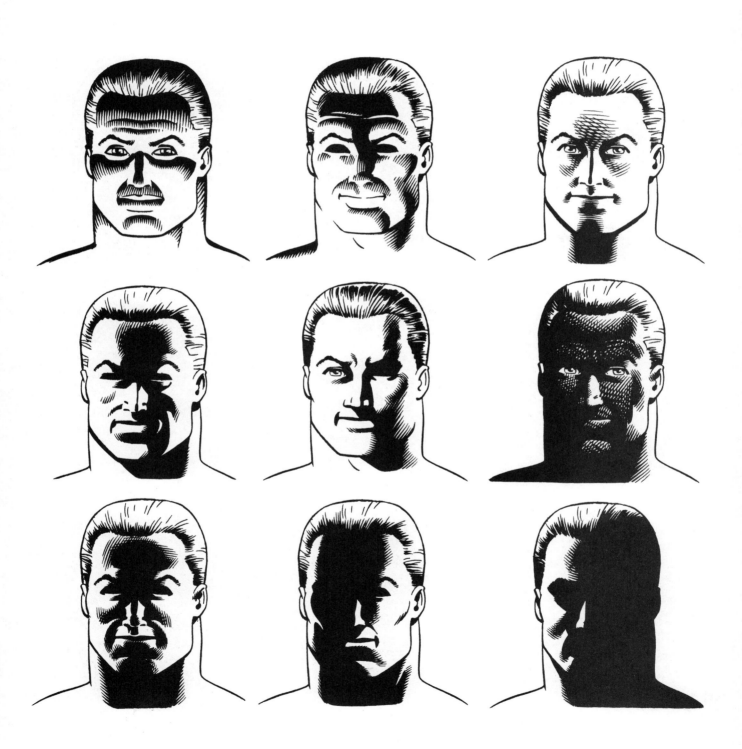

The artists whose works I based these drawings
on include Michael Golden, Dave Gibbons, Kevin
Nowlan, Wally Wood, and Bernie Wrightson.

The light sources on these heads fall into three
categories: underlight, backlight, and top-light.

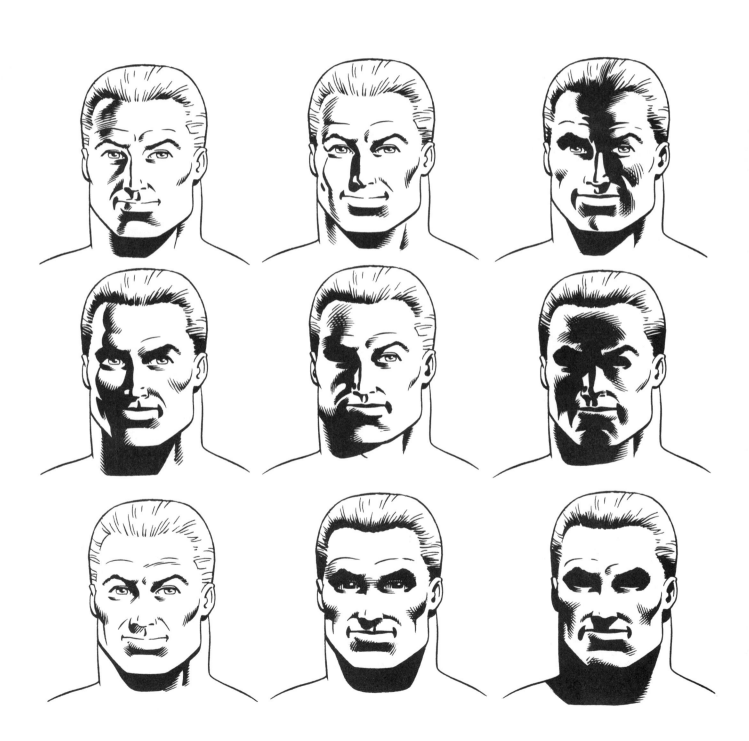

The first drawing (see page 37) is the original, unshadowed head that I started with. Notice how shadows can create different emotions and moods on the same face — underlighting, for example, usually makes a face look more menacing or mysterious.

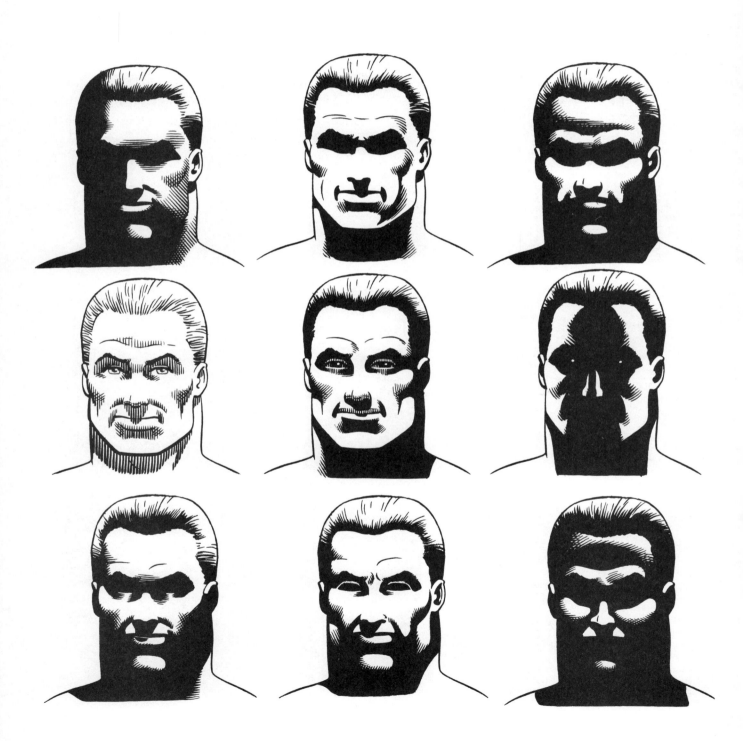

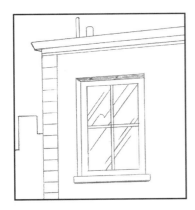

figure 57

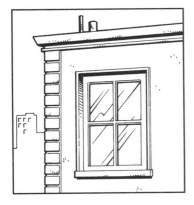

figure 58

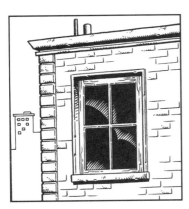

figure 59

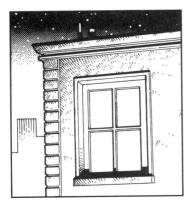

figure 60

X
INKING BACKGROUNDS

One task you'll eventually face as an inker is trying to make dull or blank backgrounds more interesting. Some pencillers don't spend much time on backgrounds, so their panels lack depth and detail. These are usually the same pencillers who only want to draw splash pages where Captain Stupendous is oozing with dynamic pyrotechnics. But good illustrators — inkers as well as pencillers — have to be able to draw trucks, dogs, coffee cups, and other real-world items just as convincingly as they draw imaginary environments. Backgrounds help define a story's mood and sense of place.

In figure 57, we see what an uninspired penciller (we'll call him Biff) may give you. This is a barely adequate drawing of a building's corner window. Your first step is to determine the time of day and the light source since Biff apparently hasn't done so. The script tells us that it's daytime, so we establish that the light is from above and to the right.

Now look at figure 58. I've dropped in shadows under the ledges by using heavy line weights as determined by our light source. Notice how three-dimensional the surface of the building now appears. The heavier contour line on its left edge also serves to create depth between the foreground and background buildings. To make the buildings less featureless, I added extra lines and texture marks around the window frame, inside the moldings of each glass pane, between the bricks, and elsewhere.

In figure 59, the building looks old and weathered. This effect is best achieved by inking as much of the architecture as you can without using a ruler. Your lines will be less crisp and straight, making the building seem older. Breaking up your lines and putting dents in the corner edges of raised surfaces also helps create a worn look. We can give our building more personality by adding

details such as bricks and some woodgrain on the window frame. Lastly, we "turn off" the lights by adding black inside the window.

What if it's nighttime, yet good old Biff gives us the same lighting that he uses for day scenes? In figure 60, we make our building much more interesting by lighting it from the streetlights below. To do this, simply place your heavier line weights on the upper edges of raised surfaces. Add a little shading in the form of texture marks to the upper part of the building then darken the night sky (in this case, I've used Zip-a-Tone.) Include a few stars — but not too many since this is an urban scene! Finish by turning on the light inside the window to show that someone's home.

By adding varied line weights and a little detail to the backgrounds, we have helped out Biff considerably and improved the overall look of the art.

Let's look at another example of how we can add depth with contour-line weight. In figure 61, Biff has given us a better background drawing by adding more detail and some blacks in the foreground. The panel still looks flat, though, so in figure 62, we create space between the objects in the room by making their contours heavier. Notice the line weight inside the door frame, the thicker lines around the middle-ground control panel, and the heaviest line weight around the foreground control panel and chair.

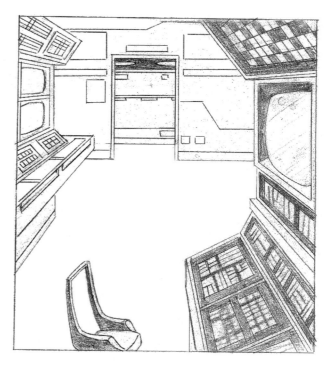

figure 61

figure 62

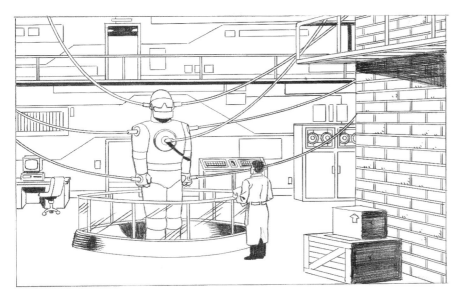

figure 63

Biff has gone all out with this next panel (fig. 63). Still, it could use some depth and texture. In figure 64, we've created depth by emphasizing the separate planes of background, middle ground, and foreground. Objects now have mass because we've added heavier line weights on their dark sides. (Not the evil sides, but the sides with less light!) Compare the different contour line weights used in the inked panel; besides adding depth, the line weights help the reader distinguish between individual objects.

We've also given this panel some texture in the inking stage. The crate in the foreground now looks like wood, for example, and the brick wall looks rougher. Bricks should not be inked with a ruler — you want them to look a bit uneven since that's how real bricks look. Try inking just the shadow sides of the bricks and notice how this raises each brick from the surface. The glass has been made more transparent-looking by breaking up the blacks and thinning the lines behind it. The

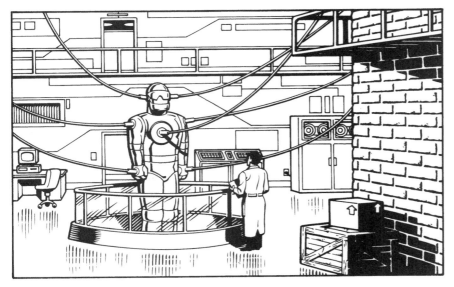

figure 64

floor is now shiny because we've added reflection lines under the objects touching it. For excellent, detailed, background inking, you can't beat Terry Austin's work.

Following are more tips on adding detail to your backgrounds.

Night Buildings

In the real world, lights rarely run in vertical patterns on office buildings at night (fig. 65). Think about it: office space is usually rented along a horizontal axis, with one or more floors grouped together. The lights on an office building should run mainly in a horizontal direction (fig. 65A). Besides, if you draw them running vertically, your buildings will look like crossword puzzles! Also remember that at night, the primary light source is coming from below (fig. 66), so rooftops should be black. Leaving a little white space between buildings on different planes helps give the panel depth and perspective.

figure 65

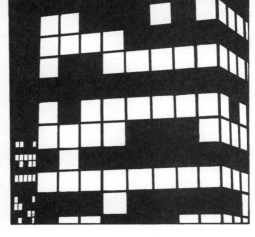

figure 65A

figure 66

figure 67

Trees and Bushes

Guess what? The same principles of line weights and blacks apply to organic objects as well as figures and buildings. Think of trees and bushes as spherical objects, then place blacks on them accordingly (figs. 67-68). Remember to layer your values and vary your contour lines to create depth between foreground, middle ground, and background. Keep leaf patterns random, with detail diminishing as the image fades into the distance.

figure 68

Outer Space

When a penciller wants an outer-space background, he or she usually just writes, "black with stars" or "BWS." It is the inker's job to create the space scene. All some inkers will do is put white dots on a black background, as shown in figure 69. Haven't they ever looked up into a night sky? Stars don't look like that!

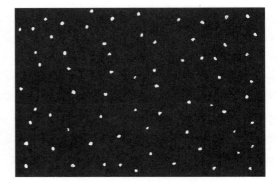

figure 69

When inking outer space, keep these characteristics in mind:

- stars are round
- stars come in various sizes
- stars are grouped together in more or less random patterns
- some parts of space contain no stars at all.

The example in figure 70 follows these guidelines. I use two different methods of placing stars on a black background. One way is to water down some white ink, dip a toothbrush into the mixture, and spray on stars by flicking the bristles with your thumb. The disadvantages of this technique are that you have to mask off everything you don't want showered with stars, and it's easy to get carried away and put down too many. The method I prefer is to hand-place each star with a brush loaded up with white ink. Just be careful not to be too mathematical in your patterns — try to keep them random. Check an astronomy book to get some idea of how real stars arrange themselves.

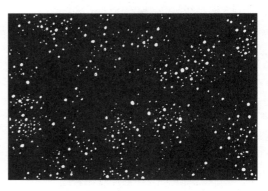

figure 70

Figure 71 is a night sky in the city. Put fewer stars in urban skies, along with a few twinkles. A city-lights effect is achieved with Zip-a-Tone that has a quick fade pattern. (See the next section for more about Zip-a-Tone.)

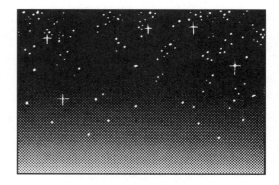

figure 71

Figure 72 shows an example of deep space. This gives you the opportunity to play God and create planets, novas, star clusters, black holes, and energy fields. Way cool!

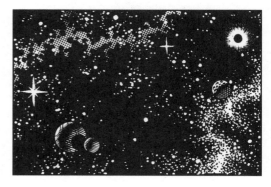

figure 72

figure 73

figure 74

figure 75

figure 76

Special Effects

Here are some tricks that'll help create different textures in your backgrounds.

- Dry brush (fig. 73):
 Wipe most of the ink out of your brush until it won't ink a line without breaking up. Then ink out from the black, using a quick, feathering motion. When the brush runs dry, just repeat the process.

- Black crayon or grease pencil (fig. 74):
 If you were ever a kid, you know how to use these. Just make sure you apply them after you've erased the page — erasers will smear 'em all over the place.

- Sponge (fig. 75):
 Take a small piece of an old sponge and dip it into ink. Soak most of the ink out of the sponge with a paper towel until there's only a little left. Blot the paper with the sponge, rotating it so you don't get a repeating pattern.

- Splatter (fig.76):
 This is the old toothbrush trick I mentioned earlier. Dip the bristles in some ink and flick them with your thumb. Always use masking film to cover up everything on the page that you don't want sprayed with ink!

- White feather lines (fig. 77):
 You can use white ink to correct mistakes as well as to add negative-space details. Thin your white ink with water (if necessary) and lay it down with a clean brush or pen. A white-on-black crosshatch pattern like the one seen here creates a unique fade effect.

figure 77

- Zip-a-Tone (fig. 78):
 Various patterns and textures come printed on transparent sheets with adhesive backs. First, figure out approximately where you're going to place a particular Zip pattern. If need be, trim the sheet down to fit the panel or page you're working on. After exposing the adhesive, carefully lay the sticky side down on the art and use an X-acto knife to cut away the areas you don't want. (See the Zip-a-Tone illustration in Chapter XI.)

figure 78

XI
ADVANCED TECHNIQUES

This chapter includes a few of my attempts at experimenting with different illustration methods. I hope you expose yourself to the wide variety of inking techniques that have been developed over the years. Studying some of the great pen-and-ink illustrators will broaden your capabilities as a comic-book inker. Some of my favorites are:

- Franklin Booth
- Walter Appleton Clark
- Joseph Clement Coll
- Charles Dana Gibson
- Frank Godwin
- Howard Pyle

To me, Franklin Booth has always been the greatest of pen illustrators. No one can match his line control and consistency. If you have trouble finding his work, buy a copy of Bernie Wrightson's *Frankenstein* book, which features an excellent homage to Booth.

I drew figure 79 in this style. Since I have better control with a brush than a crow-quill pen, I only used my Winsor & Newton series 7, number 2 on this piece.

This (fig. 80) is my ultimate Zip-a-Tone illustration. "Ultimate," because I never again want to spend two 10-hour days Zipping one piece of artwork! I used a very labor-intensive process whereby I laid down layers of Zip, matching the dot patterns to create a fade effect. This piece was done for our *Studiosaurus Pinup Portfolio*.

Figure 81 is my Burne Hogarth homage. I used a crosshatching technique described earlier (see Chapter VII, fig. 50). The original image is 11 x 15 inches. I used my trusty #2 brush for the crosshatching and a sponge for the hair. My original goal was to produce two of these pieces — one male and one female — but my hand hurt so badly after finishing this one that I gave up on that scheme.

figures 79, 80 & 81 follow on the next three pages

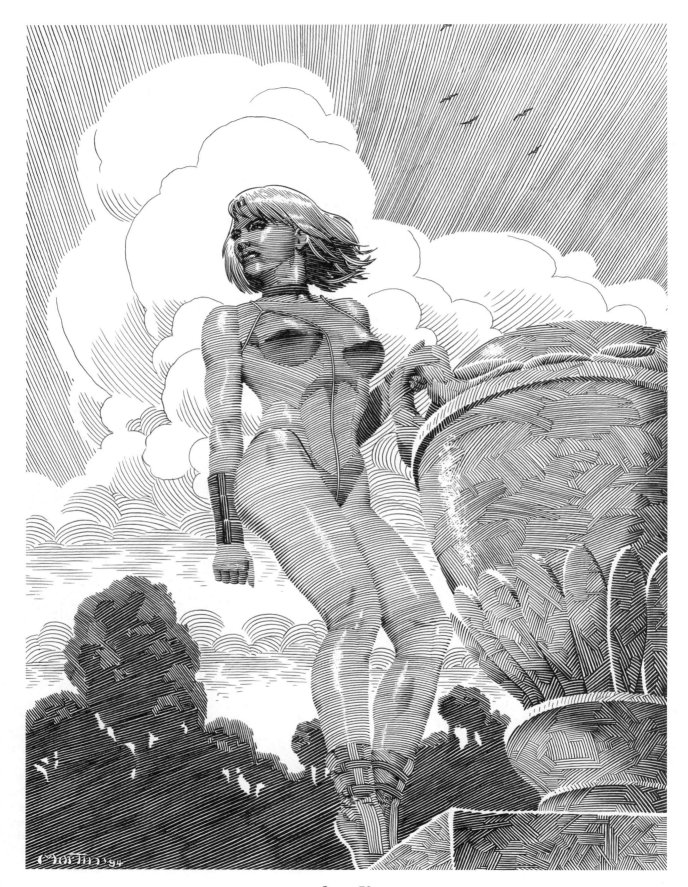

figure 79

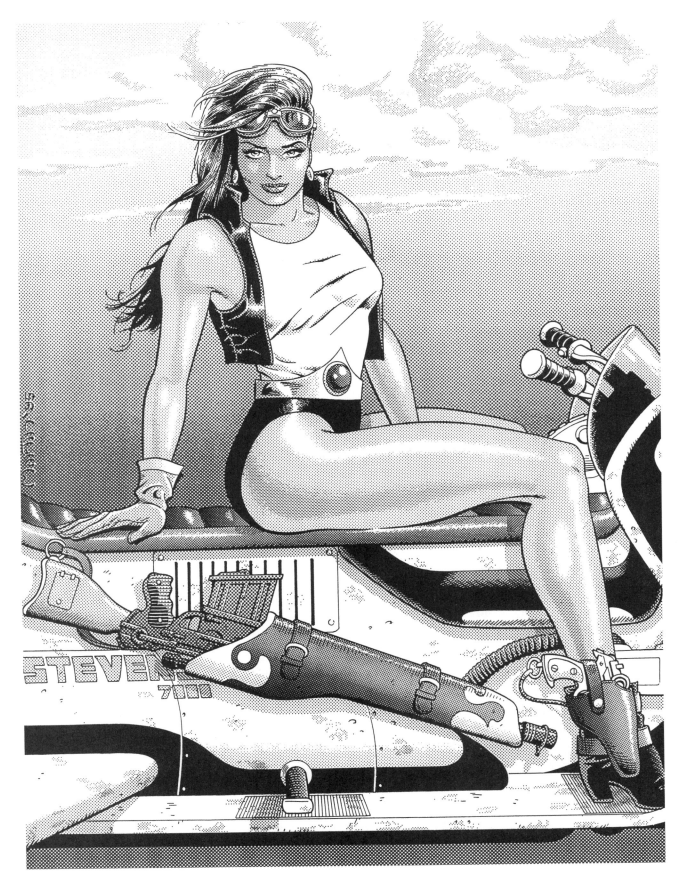

figure 80

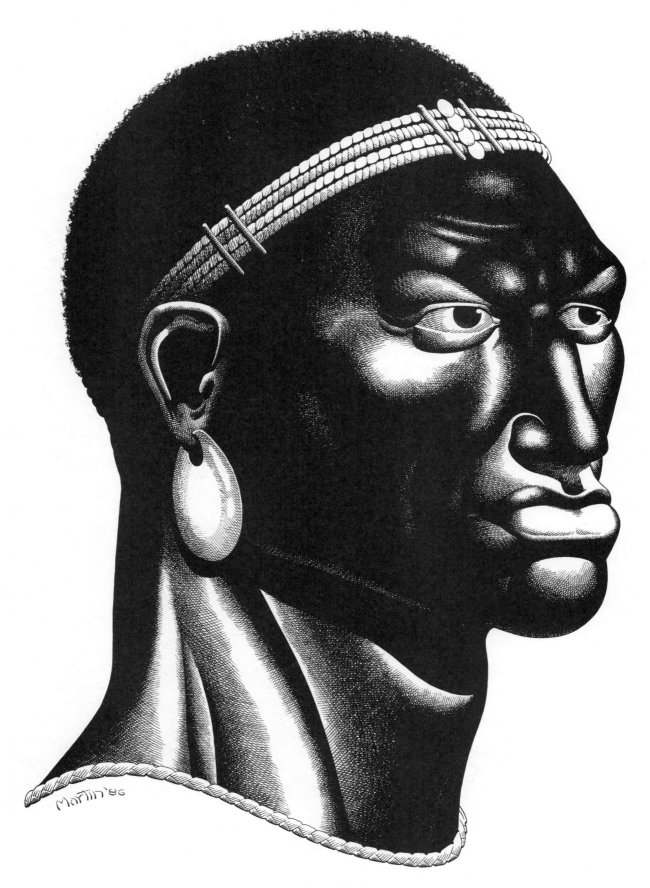

figure 81

XII
PRACTICAL TIPS

Showing Samples

If you're trying to break into comics as an inker, I recommend that you start by showing your samples to professional comic-book artists as often as possible. You can find pros at comics conventions, book signings, or local studios. Most pro artists don't mind critiquing portfolios because they were in your shoes when they were just starting out.

Sometimes artists use portfolio review as a means of finding assistants. At minimum, assisting a professional inker usually involves filling in blacks, inking backgrounds, and erasing pages. It's a great way to enter the field and learn about the craft from the ground up.

Why not start by showing your samples to editors? For one thing, artists can be more specific about how to improve your work. In addition, if you wait until professional artists tell you that your work is ready to be seen by editors, you'll have a better chance of being hired. (To find an editor at a comics convention, hang out near the freelancers — they're always trying to get editors to buy their meals. When it's time to eat, just follow the crowd. Either that, or stop by the publishers' booths and ask to talk to editors.)

When assembling your portfolio, always start with your best, most recent pages. Update your portfolio as you do new work, removing the older material. Do not include inking samples over your buddy's amateurish pencil art. It's hard for other people to discern your relative skill level when you're working over nonprofessional pencils. (Your buddy will have to break in on his or her own.)

The best approach is to ink on heavy tracing paper over photocopies of professionally pencilled comic-book pages. You can obtain such copies by

requesting them, usually in writing, from submissions editors at comic-book publishing companies. You may have to wait a while, but be patient; publishers, especially the larger ones, receive dozens of submissions and requests each week. Local artists are another potential source of photocopies.

Your portfolio should include original, inked pages (or full-size copies), along with facing copies of the corresponding pencils. You absolutely must show actual storytelling *pages*, not just pinups or splash pages. Inking a page of sequential panels is different from inking a single illustration.

Before submitting samples to a comic-book publisher, contact the submissions editor to get guidelines — then follow the guidelines. One universal rule is that you should *never* send original art in your sample packages. Send 8-1/2" x 11" copies of each inked page followed by the pencilled version. Enclose a cover letter with your name, address, and phone number. It is also a good idea to stamp your contact info on the backs of your sample pages, in case the letter gets separated from them. Once again, be patient — but don't be afraid to be persistent, too, if you initially get no response.

Essential Reading

Everyone who works in comics, or aspires to, should read *Comics and Sequential Art* by Will Eisner and *Understanding Comics* by Scott McCloud. 'Nuff said!

Reproduction

When you're working on a comic-book page with a 10" x 15" image area, it's tough to visualize how it will look when reduced down to about 6" x 9" inches (60% of original size) and saturated with color. However, you do need to be aware of how your inking techniques will reproduce at a smaller size if for no other reason than to save yourself from slaving over line details that won't be seen in the printed comic.

Seeing your work in print is the only way to learn about the many variables — reduction, coloring, paper stock, etc. — that affect how your inking reproduces. The next best method is to compare your original pages to reduced photocopies. Most copiers have a preset, 64% reduction feature, which is close enough for our purposes. This will help you see the drastic effect that reduction has on your ink lines.

Watch out for details that close up or bleed together when reduced, as well as any lines that break up or vanish altogether. An ink line thinner than about 0.3 millimeters usually won't reproduce well, and the minimum space between lines should be about 0.7 mm. The line width of technical pens is measured in millimeters, so you can use them for reference. (A #0 Staedtler tech pen, for example, has a 0.35 mm tip.)

Checking Proportions

As you ink faces and figures, sometimes you'll notice that the proportions or construction are out of alignment. It's not always easy to spot precisely what's causing the problem. A good way to find out is to look at the image in reverse: hold your page up to a mirror or turn it over and hold it up to a light. This makes it much easier to pinpoint what's wrong.

Watch Your Posture

Hunching over a drawing table for eight to ten hours a day may lead to chronic back and neck pain that can prematurely end your career. I used to get knots in my neck that were so bad, they prevented me from working for days at a time. I solved this problem by raising the surface angle of my drawing table to about 60 degrees. That way, I could sit upright and still work close to the page. It took some time to get used to this, but it saved my back and my comics career.

Erasing Pages

Another way to prevent work-related pain is to not let your inked, unerased pages stack up. Erase your pages one at a time as you finish them. This will save you major armache.

When I'm inking a page, I mark an "x" in ink on each area that will be solid black. I then fill in blacks *after* I erase the page. This helps keep the blacks nice and dark.

Working with Editors

Just like artists, editors have different working styles. Editors and assistant editors at different companies also have different job responsibilities. Identifying and adapting to these differences will make your relationship with them much smoother. There are good editors and bad editors, and you should learn how to work with both. This topic deserves its own book, but I'll limit myself to a few basic suggestions.

When an editor offers you an inking job, there are a few things you should think about before saying yes, even if every fiber of your being cries out to accept immediately! First, find out the deadline and page count. (Wait until after you've talked scheduling to ask about page rates.) Then look at your calendar to see if you can finish the job within the allotted time. Be realistic! Don't forget to allow for some time off — man does not live by inking alone. Remember that you'll occasionally run into unexpected delays. And any projects you're already working on, of course, must be taken into consideration as well. It's very easy to get yourself overcommitted by accepting too much work. When a job is due, the last thing your editor wants to hear from you is that you're late because you're working on something else for another company. You will be abducted by aliens before this editor gives you another assignment.

If you don't have time in your schedule to take on a new job, it's okay to turn it down. Tell the editor why you're saying no, and you'll earn points for honesty and professionalism. This editor will most likely keep you in mind for future gigs.

When I'm offered a job that I do have time to ink, and if I've never seen the penciller's work, I ask to look at samples before I make my decision. Many times in the past, I have regretted not doing this. Sometimes the pencils just aren't very good, which means a lot of correcting on my part; other times, I may not like the penciller's style. It's far easier to motivate myself and give 100% in the inks if I respect the pencil art.

Once you've started a job, do *not* ignore deadlines, even if you think meeting the deadline will force you to compromise the quality of your work. The most important thing to an editor is getting the work in on time — you won't keep getting assignments if you develop a reputation for being late. Do the absolute best work you can under the time restraints.

Believe it or not, neatness counts. Even when you're doing a rush job, take time to erase the pencil marks from your inked pages and to white out any stray ink lines or splotches. Remember that in some cases you may be required to ink panel borders, sound effects, and/or signage.

If, for some reason, you won't make the deadline, call your editor as soon as possible. He or she may be able to buy you a little more time or, as a last resort, find someone to help you. More importantly, the editor needs to know when your work is coming in so he or she can adjust the production schedule! Hiding from your editor by not returning phone calls only exacerbates the problem and ensures your entry on his or her blacklist.

You may be strongly tempted to fabricate some whopping lie to excuse your tardiness. *Resist this temptation!* No matter how clever and creative you think you are, editors have heard it all.

On the other hand, if you find yourself working with an uncommunicative or irresponsible editor,

don't respond in kind. Maintain a professional demeanor and send any important requests or information in writing.

Communicating with your editor from the start will make both of your jobs much easier. Ideally, an editor should be more than just someone who sends you work and nags you to get it done — a good editor is your liaison with the publisher and can either solve problems for you or point you in the right direction to solve them for yourself.

Is This the Future?

Aspiring inkers and working professionals alike always need to keep one eye on new technology, lest it catch them unawares. Computer-inking programs are already in use today. Though they're not yet cost- or time- effective, I'm sure they will be in the near future. If digital inking can save publishers money, you can bet that it'll affect the availability of traditional inking jobs.

As with computer coloring, the quality of the finished work will still depend on the computer operator's skill. Those who don't possess the skill to ink by hand will be able to ink electronically, but this will detract from the overall quality of comics art just as unskilled use of digital coloring has. The best results will come from artists who are skilled in both physical inking and computer use.

XIII
SECRETS OF THE STARS

Okay, now the fun really starts! This is where we compare inking styles from the best in the industry and read about some of the methods that helped them achieve their status.

Steve Rude has provided different pencilled pages that fall into three categories:

- The Moth (page 58) is drawn in a Jack Kirby style
- The Nexus (page 74) is in Steve's regular, tight pencilling style
- The Sundra and Jil (page 90) is an unfinished layout

This is the part of the book that I've been looking forward to the most. Even though I contributed to this section (hey, I wrote the book!), I will be studying these inked pages for years to come.

Before you read the rest of this chapter, you should know a little about the processes behind it. Normally, comic-book artists ink directly on the original pencilled page, but for this book, we needed to reproduce Steve's original pencils so you could compare them to the inked versions. Consequently, none of the artists in this book inked on the original pencilled pages, which made their task more difficult.

Each inker was provided with a photocopy of the page to be inked. The pieces were done by inking on tracing paper over the copy, or by putting the copy under regular comics art board and inking on a light box, or by inking on a nonphoto-blue copy of the copy.

To keep myself from being influenced by what everyone else was doing, I inked my pages before the others started to come in. I have to admit that I was tempted to change a few details on my pages when I saw what some of the other artists had done. But none of the other contributors had this advantage, so I resisted the temptation. My Sunday-school teacher would be proud!

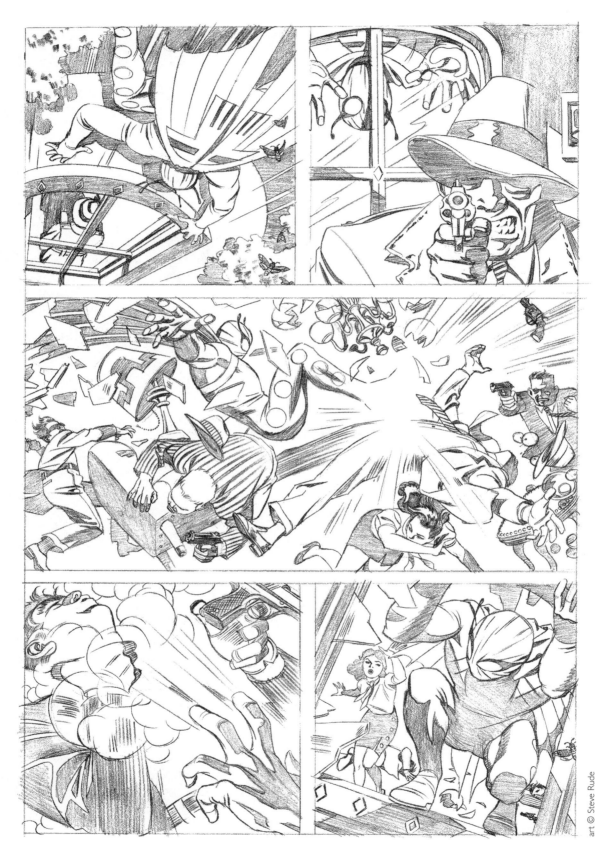

figure 82

THE MOTH

Inks by

Mark Farmer
Gary Martin
Joe Rubinstein
Karl Story
William Stout

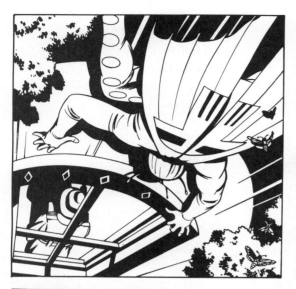

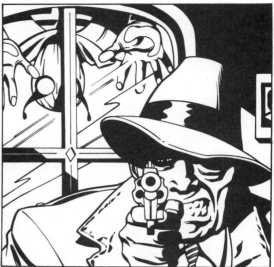

Mark Farmer

Personally, the most important part of inking is to talk to the penciller as much as possible. This allows the artist to let you know what he expects from an inker, whether he's seen anything of yours in the past that he may or may not like to see repeated on his own work and at the same time point out things you should be aware of in the pencils. It's also nice to see if there is an intelligence at work on the page, if the penciller has mimicked someone else's style to a fine degree or even just swiped panels/pages without thinking anyone would notice.

Sadly, these days so many "hot shot" artists don't understand their own job, let alone that of the inker.

If asked to stay true to the pencils, I don't think that it's too much to expect the pencils to be of an acceptable quality. After all, your name is on the credits, too (I'm always a bit wary of being asked to ink someone whose work I've never seen in print . . . a diplomatic request to see Xeroxes of the job in question is a good idea before saying yea or nay).

Nothing is more soul-destroying than to see a comic you've busted a gut over, trying to do as good a job as you can, ruined in the printing . . . or worse still, a job where the coloring selfishly obliterates the line work.

When approaching the page, I tend to throw down all the major outlines first, gradually working smaller and fine on the remaining middle distance and background figures. Some days, when feeling particularly alert, I may decide to just ink faces all day . . . (One of the first things Alan Davis made clear to me was that as long as I inked his faces and hands as closely as possible to his pencils, the rest was secondary. Anyone lucky enough to see his pencils firsthand will know that there isn't a great deal of room for error. Some days I feel microsurgery would be light relief!) I still make the mistake of feeling a page is completed even though I still have the backgrounds to do . . . that's the work best left till 2:00 in the morning when your concentration is starting to wane. Occasionally, I may start at the bottom of a page, especially if the pencils appear easily smudged, but usually I start at the top and work down covering "sensitive" areas as I go.

Most of my work is done with a brush for both speed and accuracy . . . Winsor & Newton, series 7, numbers 00, 0, and 1.

I use a dip pen for really fine lines and texture effects . . . Gillot nib no. 170 (I have two really good nibs I save for special occasions. They are still produced, but the metal used is different, and the line quality varies too much on the modern variety, so I'm trying to make the old ones last as long as possible.)

I use Rapidograph pens for straight lines on things such as machinery or buildings in backgrounds . . . numbers MO5 and MO35.

I also use Fountain Pentel pens for their ease of use and the fact that a line dries almost as soon as it's put down on paper.

The most important tool I use is white gouache . . . for correcting mistakes and giving a page a little polish once it's been erased, and I can see where the weight of line isn't as accurate as I'd like it to be.

Some of the everyday problems an inker can face include:

- Poor quality paper . . . Some paper stock may look good, feel smooth to the touch, and take pencil real well, but for some reason it will not take ink at all. Some paper is very greasy and absorbs oil off the pencillers' fingers no matter how careful they are (and believe me, there are some *really* slimy artists out there). Quite often pages in the same batch can vary in quality; some will take a brush line but not a pen line and vice versa.

- Bad ink . . . too watery, where the pencils sometimes remain darker than the inks, or too thick, where the brush gets clogged up after only a few minutes' use.

- New brushes . . . It's very rare that I find a brush is "ready to use" as soon as I pick it up for the first time. It usually takes a couple of weeks' use before it's at its best. I always feel a little sad to throw away a brush that's been very responsive right from the start, mainly because it may be some time before I come across a brush so easy to use in the future.

- Uninspiring pencils, probably resulting from uninspired writing. 'Nuff said!

The main problem while working on the Steve Rude page was the fact that the "original" was only a Xerox, not actual pencils on artboard, which meant inking on a piece of vellum taped over the copy. Vellum tends to buckle very easily from either moisture off the inker's hand or from the ink as it dries (and it dries very slowly because the vellum doesn't absorb the ink at all but just lets it lie on the surface). As well as that, vellum picks up grease very readily. All in all, a bit of a nightmare, so what you see is, in fact, a copy of a copy that I've tidied up to look as it would had I inked on the actual pencils.

The actual pencils' style, so familiar to Steve Rude fans out there, was no problem, but I'm not sure my inking suits his pencilling . . . I feel he needs someone with a looser technique. My efforts look a little sterile when applied to such highly finished pencils.

The future of inking? I'm just waiting for a computer software package to replace us (the same way lettering is becoming a typing skill instead of a calligraphic one). Then I can wash out my brushes for one last time, sit back, and watch the comics medium lose yet a little more of its soul.

"It's also nice to see if there is an intelligence at work on the page, if the penciller has mimicked someone else's style to a fine degree or even just swiped panels/pages without thinking anyone would notice."

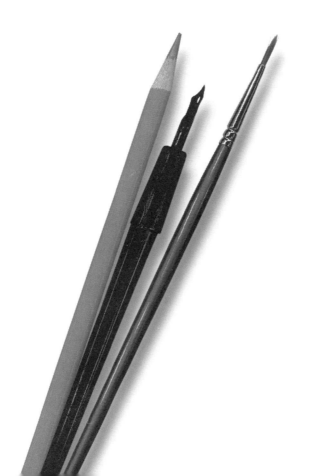

Gary Martin

Since the Moth page was drawn in Steve's Jack Kirby style, I tried to ink it as if I was inking the King himself. My contour lines are bolder than I would normally use. And to contrast this boldness, I like to use delicate feathering lines within the figures.

I used my number 2 Winsor & Newton for everything except the ruled lines where I used a .35 technical pen.

This page is so complete that my only contributions are small details. In panel one, I added leaves to the bushes with white-out.

The thug in panel two has a thick contour for separation, and so does the Moth in panel five.

A cool approach that Steve uses in panel three is the "light emanating from the force of the blow technique" that Jack used so well. This is where the light source actually radiates out from the punch or kick epicenter to show its power. So notice how I used this light source to determine my line weights.

In panel four, to achieve the looseness that Steve has in his pencils on the arm that is holding the throat, I used white-out on the black sleeve for feathering.

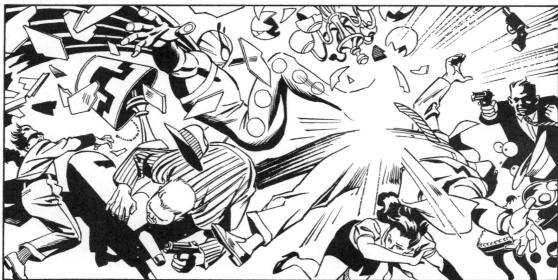

Joe Rubinstein

My materials are:

- Pelikan Yellow Label Ink for brush work
- Higgins regular ink for pen work

Pens -
- Hunts #108 mostly on this page
- Gillot #170 for some of the backgrounds

Brushes -
- Kolinsky Raphael series 8404 and 8408 #2 & #3

I use a KOH-I-NOOR® pencil holder (claw grip) to hold my pen points, Magic rub erasers, Pelikan graphic white for touchups, single-edged razor blades, a KOH-I-NOOR® electric eraser (dark gray erasers), and an 18" raised metal ruler for backgrounds (but I do as much as possible freehand).

My philosophy of inking is to follow the pencils as closely as possible if I respect the work, and in the case of Steve Rude, I do respect the pencils.

An inker is not a tracer, the movie *Chasing Amy* aside. He/she is *an artist with ink* (if done right), just as the penciller is an artist with graphite.

Inking is far too boring if you do it the same way all the time.

The better inkers know how to draw (and very often can pencil comics as well), and the better inkers (in my opinion) don't overwhelm the penciller's work — they give it the respect it deserves and let the pencils dictate how to proceed: with brush or pen, angular or fluid, sensual or brittle, bold or precise, etc., which leads to my inking on Steve's page.

Steve is so tight and good that he didn't leave much room for interpretation or self-expression (nor should he have). If the penciller had been less exacting and informative than Steve, I would have been forced to make my own choices — about line weights and degrees of detail, etc. — consequently causing the work to become more "mine" than "his."

Like an actor in a very well-written play, I make the part my own, but ultimately, I hit the lines right and don't bump into the furniture.

Karl Story

My tools:

- Raphael Kolinsky sable brushes #8404, usually a number 2 or 3
- T. Ishikawa Zebra quills #2586
- Brause quills #511
- Rotring Rapidograph pens .18, .25, .35, .50, and .70
- Higgins Black Magic india ink
- White acrylic paint
- The full compliment of various templates, straightedges, compasses, and other drafting tools of the trade

My approach to inking is to try to make the penciller look as good as possible. Pretty simple. To do this, I cannot ink every penciller in the same way, so I try to adjust my style to fit the particulars of each individual penciller. Sometimes this takes a few pages to get acclimated with a new style. Having never worked over Steve Rude before, I found it a bit awkward at first, especially working over a blueline of the actual pencils. It took me back to when I inked sample pages over photocopies with vellum or mylar overlays.

I try to go for a clean look with my finished inks. I am primarily a brush inker, finding it to be the most versatile of available tools. Brush is used for organics, such as the characters, animals, and other non-manmade things. A quill is used for very small figures and rough or broken things like shattered glass or rubble. Technical pens are used for all things artificial like buildings, guns, cars, etc. This is only a basic outline, and I frequently break it to get the best results.

The finished page should be clear and easy to understand. I use line weight to distinguish depth in the page, thicker outlines on the figures and objects in the foreground, and thinner in the background. The artwork should be able to stand on its own in black and white even if it is to be colored later.

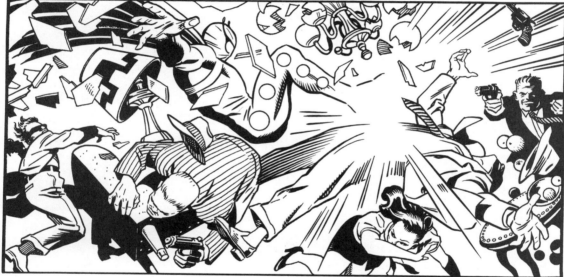

William Stout

I draw my comics on three-ply, kid-finish, Strathmore paper, using the slightly smoother side.

I pencil lightly but precisely with a 3H pencil (most any handy brand); if more detail is needed over these pencils, I go back with a softer and darker HB.

I erase the pencils with a Magic Rub eraser.

85% of the art was inked with a Winsor & Newton series 7 #1 brush. There are few pleasures in the world that match inking with a brand-new, finely tipped, series 7 #1. (Be sure and test your brush before purchasing it. If you dip the tip in water and then flick the body of the brush sharply against your arm, the brush should come to a perfect point with no split hairs. If it doesn't, don't buy it — it'll split on you very soon after use.)

The rest of the art was inked with a standard Hunt #102 Crow-quill pen.

The exterior panel borders were inked with a 5-1/2 B Speedball pen (the heavier line helps slightly to unify the look of the page); the interior panel borders were inked with a 6 B Speedball pen.

On this page I used Higgins T-100 Drafting Film Ink because it was handy and was pretty black. I usually use the intensely black (and ruinous on your pens and brushes) Pelikan Drawing Ink for Matte Drafting Film. These inks take a sandblaster to remove, but they don't gray out when you erase your pencils.

I have a set of ellipse guides for drawing and inking ellipses when that kind of precision is needed. I use a #3 Rapidograph for inking ellipses. I ink straight lines using a crow quill and the edge of a clear, plastic triangle. To keep ink from creeping under the triangle edge, I have placed several layers of thin white tape (just back from the edge) on the underside of the triangle to raise the inking edge slightly away from the paper. Occasionally I make use of a French curve for inking long, precise curves.

I do very little white-out work (I try to get it right the first time), but when I do, I use Winsor & Newton Designer's Gouache Permanent White.

I basically have three different approaches to comic-book inking:

1.) Stay as true to the pencils as possible. The only deviation in this case would be to "clean up" the pencils by using a ruler or ellipse guide where mechanical elements of the imagery requiring that kind of line precision were drawn freehand by the penciller. Example: My inks over Jack Kirby's pencils in *Demon* #15. Why intrude on the style of a master?

2.) Aid the penciller in achieving a particular sought-after style. In this case, the pencils indicate a certain known final "look" or style. Example: My inks over Jim Sullivan's pencils to "Take One Capsule Every Million Years" *(A-1 #5)*. It was obvious that Jim was going for a very Frazetta sort of look, so I inked it accordingly.

3.) Imprint my own style upon the pencils. I do this if the pencils are vague (as when I am given what amounts to layouts to ink) or weak in drawing. For example: My inks over Pete Von Sholly's pencils on the cover to the 3-D comic

TyrannoStar. Pete invited my participation and contributions to his cover.

In approaching the Steve Rude page, I combined approaches 1 and 2. Steve's drawing is generally clear and strong, requiring little more than a clean interpretation of his lines. However, it also looked as though Steve was deviating somewhat from his own style and taking a very Jack Kirby approach to the pencils.

Because I didn't work from Steve's original pencils, I had to transfer his Xeroxed pencils to my Strathmore. It was this part of the job that was the biggest pain-in-the-ass. I taped the Xerox to the back of my Strathmore. Then I traced the pencils onto my Strath sheet using a lightbox. After that, I repencilled the whole damn thing so that it matched as nearly as possible Steve Rude's original pencils. Boy, was I glad to get inking!

Panel one: I deviated from Steve's pencilling of the bushes because for me they were too vague and not clearly readable as bushes. Since this page is in a "cartooned" style (as opposed to a "realistic" style), I redrew and then inked what are generally accepted as cartoon symbols for realistically cartooned bushes. This whole panel was inked with a pen except for a bit of the Moth.

Panel two: This is all brush except for the window, the gun, and the picture frame. I really like Steve's indication of the Moth guy's palms and fingertips pressing on the glass.

Panel three: This panel is 70% brush inking. I got a little carried away and used my circle template not only for the chandelier bulbs but for the spilled fruit as well. The power streaks emanating from the impact center were all inked using my triangle edge.

Panel four: The normally fine drawing by Steve was a bit off on two of the hands, so I redrew them correctly in his style. I feathered one side of each of the crease highlights on the black coat because they needed contrast and because without the feathering there were two many hard edges, causing the creases to look artificial. About 80% of this panel is brushwork.

Panel five: About 80% brushwork, this panel was pretty much inked "as is" with only a few additions of feathering on the hero's knees to sweeten the form.

A couple of final notes: a really good exercise for inkers is to try to make your pen lines look like brush lines and your brush lines look like pen lines. Also, when I pencil for my own inking, I pencil as tightly as possible. The more you work out in the pencils, the fewer hassles you'll have when it's time to ink. Your original art will look a lot cleaner and won't be piled up with white-out.

"I basically have three different approaches to comic-book inking: 1) Stay as true to the pencils as possible. 2) Aid the penciller in achieving a particular sought-after style. 3) Imprint my own style upon the pencils."

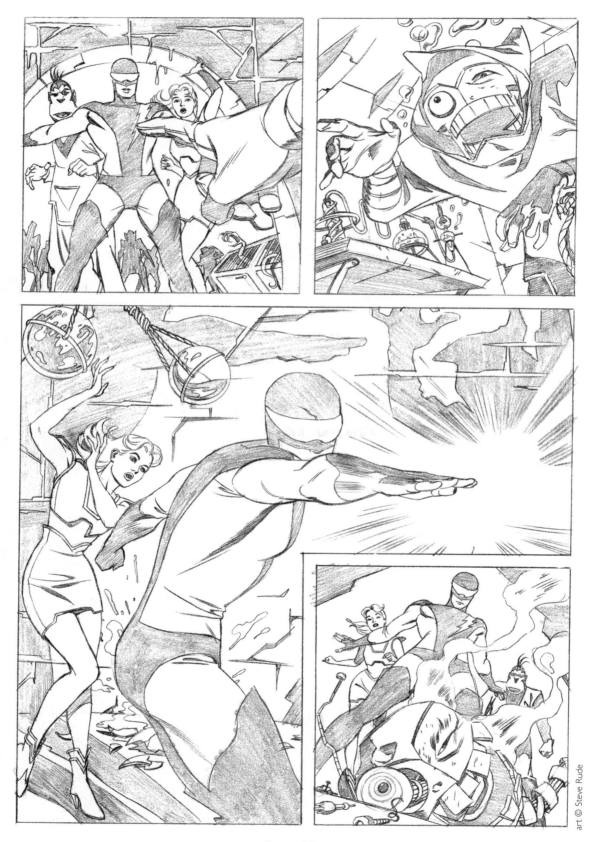

figure 83

NEXUS

Inks by

Terry Austin
Gary Martin
Tom Palmer
Steve Rude
P. Craig Russell
Scott Williams

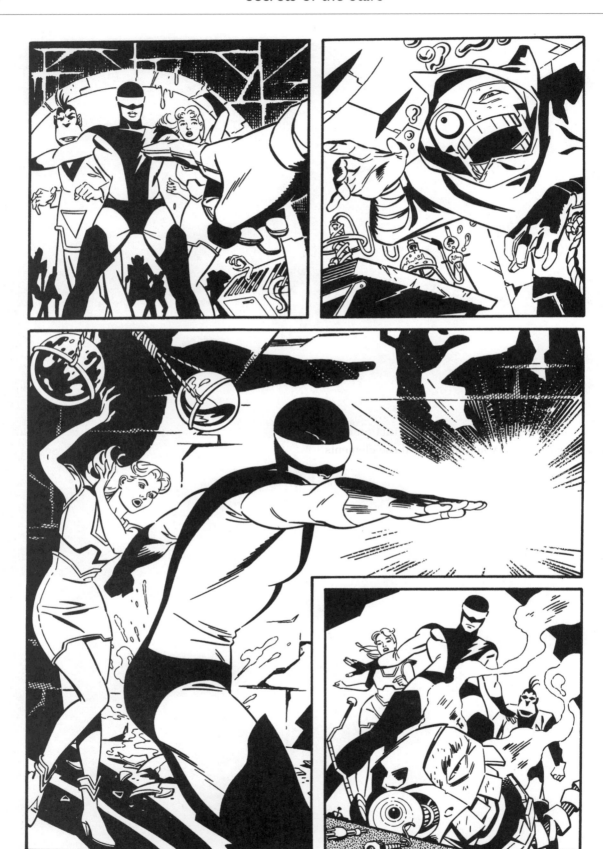

Terry Austin

To me, once you boil it all down, the main function of an inker is the same as the rest of his collaborators in this process, namely that of storyteller.

My job is to take whatever elements the penciller has decided best serve the function of telling the writer's story and to clarify those elements in order to support that storytelling function. This is accomplished by ordering the space in the panel — usually by varying line weights on objects to correspond to their relative positions in the panel — and organizing a sequence of dark-to-light areas to indicate a sort of atmospheric perspective, and using different kinds of lines and textures to contrast the various materials things are made of. These days, you can tell the folks masquerading as inkers; there's a million lines everywhere and all of 'em look the same.

I'm afraid I have no use for inkers who decide they know more than the penciller and start "correcting" things to feed their bloated egos. Even if their assumption were true, the pencils on the page are what the company bought and paid for and were approved by the editor, also known as the boss. Presumably, those pencils — albeit enhanced by my ability to manipulate the elements listed above — are what the editor wants and expects to see when I'm done. I feel that when I've done my job correctly, my contribution

should be invisible. Hopefully, unless there's a return to check the credit box, the reader should have forgotten I've ever been there. To me, the biggest compliment is when someone says, "Hey, I didn't know you inked that — I thought so-and-so inked it himself!"

In approaching the inking of this page, I had to bend two of my personal rules concerning the acceptance of work:

1.) No inking on blueline pages. For the uninitiated, blueline pages are basically Xeroxes of the pencils on comic-book art paper but printed in non-reproducible blue ink. This blue ink has a sheen that resists ink just about as stubbornly as those grease-laden sheets of waxed paper that remain in the bottom of the box after you've eaten your pizza. My rule of thumb is to tell the inquiring editor, "Sure, I'd love to ink some blueline pages, but only after you allow me to stand behind your chair for the next five hours whacking you in the back of the head with a rubber spatula while uttering an annoying 'Boingy, boingy, whee!' sound." Strangely, no one has ever accepted this offer — until Gary, that is. You might want to drop him a line in the sanitarium and tell him how much you appreciate it.

2.) Unless unavoidable, no inking of unlettered pages. At least one major company has been flim-flammed into computer lettering their books and marrying the balloons to the finished art. Not only is the lettering deadly dull, but how can the poor inkers successfully fulfill their function as story-tellers if they don't even know what the story is about? Besides that, it takes about a third longer to ink an unlettered job — thereby making the book later than ever — the inkers complain that they don't know who might be speaking in the panel, don't know what the important elements are in the panel to direct the reader's eye, and, in fact, may not even know who the characters are on the page. Fortunately, in this instance, I've read every issue of *Nexus*, so I can readily identify Nexus, his uh, sister Brenda, and their um, monkey-faced, interplanetary, beatnik-pal

Geezba — I'm kidding, but you get the idea, right?

Gary asked us to be specific about the tools we used, which I generally refuse to do because I don't think it helps those trying to learn to ink. My advice is to try anything and everything then narrow that down to the things that produce the desired effect. Use an old fence post if it works for you.

On to the page . . . Steve Rude's pencils are really quite lovely, very tight, which is a word inkers use to mean "complete." I prefer tight pencils as that allows me to concentrate on line weights, textures and the like, without having to stop and figure out, "is that his other arm or a branch of the tree he's standing in front of," or some such.

Panel one: Steve is genius enough at design that he can load heavy black areas in the foreground and background in the same panel and make it work. All I did was add a bit of feathering out of the shadow on the foreground hand to add a hint of detail to differentiate it from the simpler linear figures of Nexus and friends. I also left a slight halo around the hand to pop it forward and — as an experiment as I've never inked Steve's pencils before — I tried a hint of rougher texture in the black of the stone wall behind them, confident that if this were for publication in an actual comic book, that whole area would likely be eventually covered with lettering anyway.

Panel two: I haloed the floating figure to pop it forward and roughened up the line work/texture of the wooden table.

Panel three: I added the grays in between the background shadow sections to contrast with the stark, black-and-white areas and pulled a couple minor blast lines — in white — across the hand area of Nexus' shadow to help reinforce the illusion that it is the furthest element in the composition, existing well behind the action.

Panel four: I added a gray tone to the foreground

to bring it forward and to help anchor the smashed head to the ground/foreground.

In conclusion, I'd just like to add that I suspect inking is much the same as dancing; if you think too much about what you're doing, it spoils the flow, robs the process of whatever magic there is. But then again, what do I know — I can't dance a lick!

"I feel that when I've done my job correctly, my contribution should be invisible. Hopefully, unless there's a return to check the credit box, the reader should have forgotten I've ever been there."

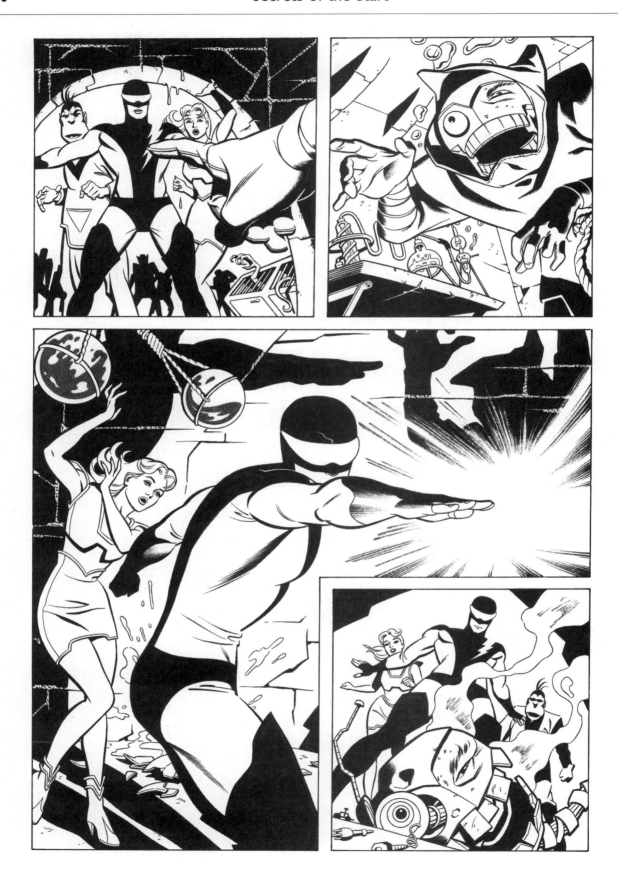

Gary Martin

I admit I have an unfair advantage over the other artists when I inked this Nexus page. By my estimate, I have inked about 400 of Steve's pages. Inking a page of someone you have never inked before (especially over a Xerox) is very difficult because it takes several pages before you start to feel confident in your approach. In my case, when I first started inking Steve in 1991, it took me about two issues before I felt like I was getting it right.

Steve wanted my inks to be more loose, somewhere between Alex Raymond and Mike Royer. My natural approach is to be very controlled, so I had to work really hard to loosen up for him. Steve does not like slick feathering. He prefers dry brush, so I try to use it as much as possible.

One of the things that I always have trouble with is inking Sundra's face. Her face has such simple features that just one subtle mistake throws off everything.

Of course, I used my trusty Winsor & Newton, series 7, number 2 brush on 98% of this page. And a Rotring Rapidoliner, size .35 technical pen to template the circles.

In panel one, I added a white contour line on the bottom of the large hand in the foreground and a heavy black contour on the top of the hand. This helps pop out the hand from the middle ground. I put Zip-a-Tone on the wall cracks to push it back.

The creepy guy in panel two was missing an eyebrow (see the pencils). So, I grew it back. And I softened some of the edges on his black areas with dry brush for texture.

Panel three has a strong light source, so I added a heavy contour on the left side of the figures. And I removed the shadow below Sundra's knee to be consistent with the light. Notice the contour line weight on Nexus' raised arm. (The heavy part is away from the light, and the thin part is toward the light.) I added white Zip on the hanging spheres for separation.

In panel four, for depth, I added a heavy contour to the severed head. (Cool! I got to write the phrase, "severed head"!)

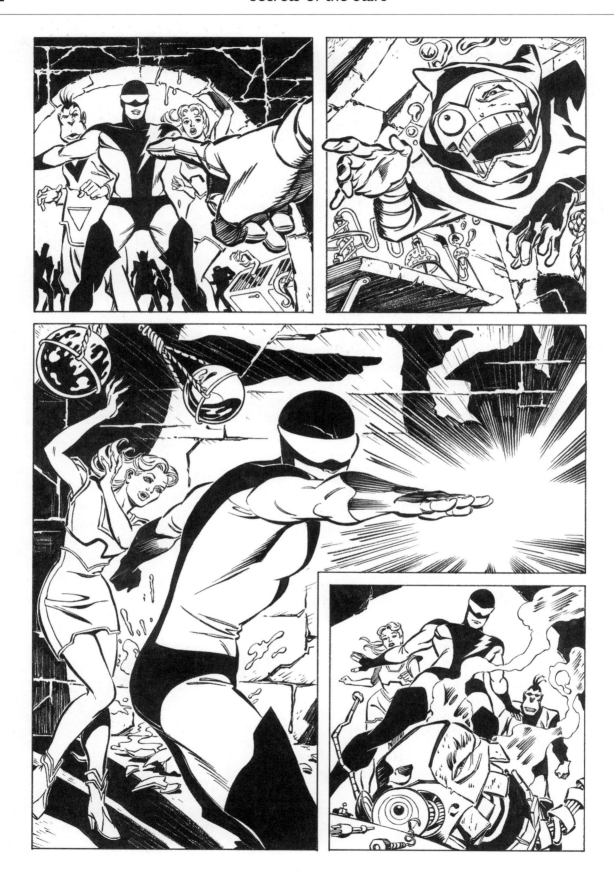

Tom Palmer

This was a difficult assignment. Steve Rude rendered a very tight-pencilled page, leaving little for the inker to demonstrate beyond basic, technical skills, or so it seems. I have been assured that styles will emerge based on other submissions, and that the tight pencils were intentional.

Normally, at least in recent years, I have worked over breakdowns or layouts, providing finishing inks. Working over breakdowns or layouts usually requires some pencilling by the inker — sketching in areas not defined, or plotting light and shadow on figures or backgrounds. Either way, I find the involvement taps my interest and energies.

I enjoyed this chance to work with Steve Rude. The collaboration was rewarding for me. I have admired his work for some time, and once I got into the inking, I did not feel restricted but challenged to do my best.

I chose to trace my version on Bristol board over a light table, using a photocopy of the pencilled page as my guide — not a usual procedure, but convenient when an original is not available. I find this practice analogous to staring into a brightly lit TV screen for hours!

Some may define inking as tracing every line exactly in weight and character, and by definition,

I suppose there is some truth in that. Inking Steve's page, I wanted to transcribe his careful pencilling, but I also wanted to apply some of my own technique for this book's interpretation.

I began by tracing most of the line work in pen, using straightedges and templates to capture the mechanical elements of the circles and ellipses correctly. I then added the dense blacks with brush and removed the Bristol board from my light table. I used a brush to render the energy flare, and the edge of a wood ruler to guide my brush for straight lines.

The last stage had me sit back and take an overall look at the page and see how each panel related to the whole. The hand in the first panel is the same hand of the creature in panel two. Taking some license, I broke the panel border with the creature's index finger in the second panel, which not only gave a connection to the first hand but a dimensional quality to the figure overall.

I took a single-edged razorblade and scratched radiating lines into the large, black, wall shadows in panel three. Breaking up the solid black brought the Nexus character forward, the blacks of his costume now dominating. I used a brush in the last panel to finish details but decided at one point to leave well enough alone. I was satisfied with the results. Hope Steve felt the same.

I am constantly trying new materials and discarding those that fail to achieve the results I want. On this assignment, I used a Hunt 102 artist's pen point and a Gillott #303 pen point for the freehand rendering and a Staedtler Marsmatic #.70 technical pen for the hard or mechanical elements. A #4 Isabey 6227Z Kolinsky sable was the brush I used throughout.

I find Pelikan drawing ink free flowing with pen or brush, and Design Higgins Black Magic a dense black for large passages. I have a jar of Pelikan Graphic White for last-minute touchup and white-out.

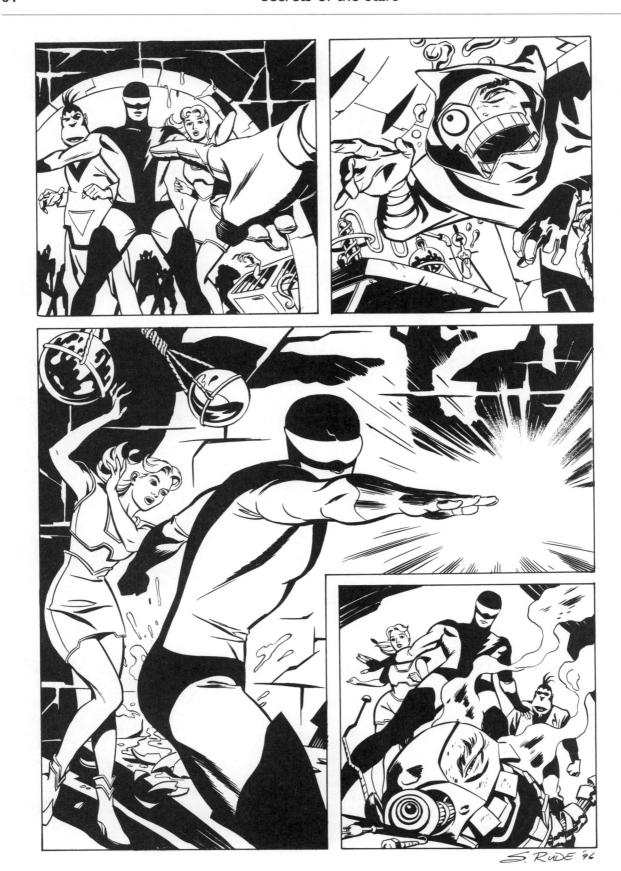

Steve Rude

Main tool used: Cosmos-Extra #4 brush

I was asked to ink two pages of my own work for this book. Both pages were inked on vellum — a thicker version of tracing paper — that was spray mounted over Xeroxes of my pencils. I used a Cosmos brush #4 for 95% of the work. A small, stiff pen nib filled in some detail areas.

All the figures, even the tiny ones, were done with a brush. Believe me, it's not as easy as it looks. Professionals and amateurs alike know that one misplaced line can change everything. Be prepared to white out what needs to be corrected.

Two completely different approaches were used to ink these pages. Here, on the Nexus page, everything was outlined first and blacks filled in after. On the Sundra page (see page 102), the black areas were "spotted" first and outlines saved for last. Both approaches produce different results.

The two things I look for in all my work — pencilled, painted, or inked — are *readability* and *emotion*. These two qualities combined must have a certain impact for me; a well-drawn figure with anatomical correctness and mechanical feathering can be boring, so achieving this impact can be a challenge for me, since I like realistic-looking figures. I'm always open to new ways of conveying the "emotion" of a scene better.

Perhaps you'll invent a new way that will become the standard for other inkers to follow.

If you like my style of inking, the following are several old masters you can refer to: Noel Stickles and Milton Caniff for black spotting, Roy Crane for simplicity and overall page design, and Alex Raymond for cursive, yet accurate inking. Also, see Rip Kirby.

Take care and good luck!

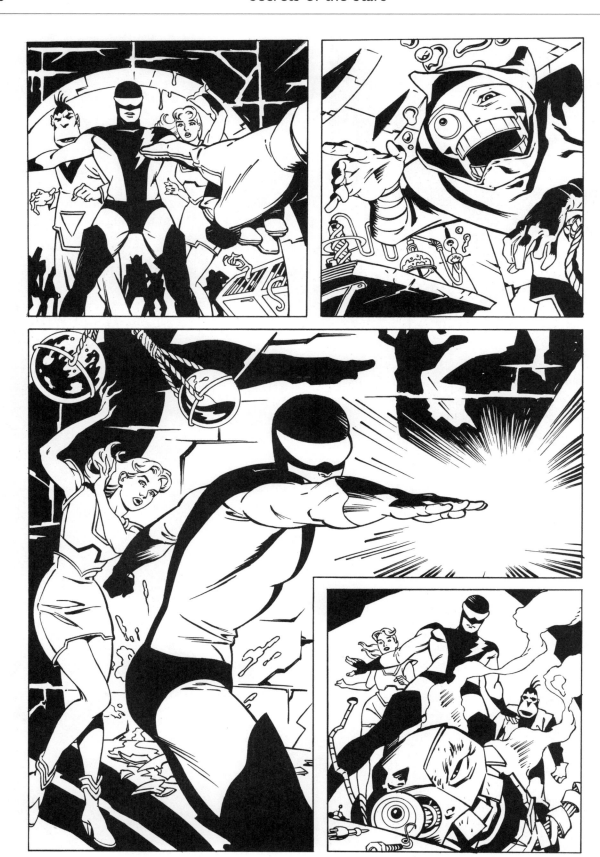

P. Craig Russell

My materials are simple. A Hunt's #108 Flexible Crow Quill. That's it.

Sometimes people have a hard time learning to use a pen and give up too soon, but I can offer at least two suggestions for making it work.

1.) The type of paper you use. It needs to be smooth. A paper with too much tooth is hopeless. This can be a problem if you're so cheap you'll only use paper provided by the publishing houses (though recent years have seen an improvement from most of them, I still buy my own — a nice, two-ply, slick, Strathmore — by the sheet, not in pads).

2.) The position in which you hold the pen. It took me years to realize that students were holding it as they would a pencil, almost straight up and down. This causes the point to splay and catch in the paper. You must hold it at a much lower angle so it can glide across the page.

My intent as an inker is to always respect the integrity of the penciller. I am here to help them "realize" their pencil drawings. I'm not here to impose my own vision — I can do that with my own work. This is supposing, of course, that the penciller has clearly stated his intentions in his drawings, has said what he meant to say, clearly. I don't mean to imply that it's just a question of

going over the lines with ink. The inker needs to be so sensitive to the forms he is inking that it feels as if he is drawing it himself. It's not unlike the conductor who feels he has actually composed the music he is conducting as he conducts it. This is why the more an inker knows about drawing, the better he will understand and translate into ink another artist's work.

I haven't addressed the question of what to do with sloppy, poorly thought-out pencils. I don't want to. It's too depressing. Don't make me.

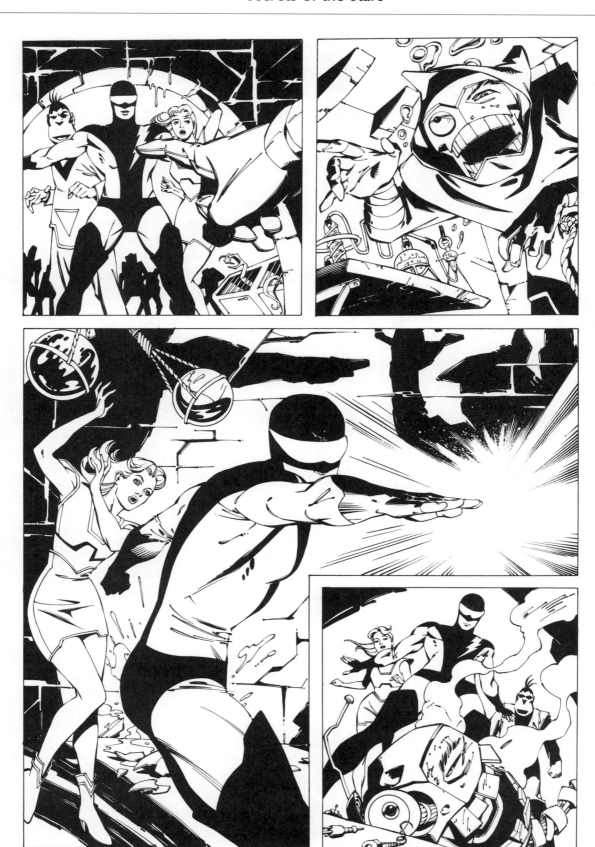

Scott Williams

Inking comic books is a strange little profession. It's an art form that is easily and frequently misunderstood, generally underappreciated, and tediously laborious. It can also contribute to sleep deprivation — late pencillers and a pesky little thing called a deadline being the contributing factors.

So, what's the upside here? Why ink comics? Why not *pencil* comics? Why not soak up some of that fame and glory and fortune for yourself? Why be a bottom feeder when you could be the star?

Is it because you get to work side by side with other incredibly talented artists and create something as a team that is better than could be created individually? Absolutely.

Is it because yours is the line that is actually reproduced by the camera and seen by the masses and the incredible control and power that gives you? Positively.

Is it because inking is easier than pencilling? Yeah, that too.

Starting at ground zero, with a blank sheet of paper staring back at you, is a lot more intimidating than staring at one that has all its storytelling, camera angles, designs, and lighting already worked out. Does that mean that inking is just about tracing somebody else's line? At times, yes.

Some artists pencil so tightly and completely that their work is practically camera ready before the inker ever gets his hands on it. Although the finished image is usually impressive in such a case, the inking process is usually tedious and dull, with no room for inspiration, interpretation, or spontaneity.

Ideally, there is a middle ground for inkers, where the pencils are complete and draftsmanship solid, but the inker is left enough room for decisions regarding line weights and contours, bounce and energy, as well as texture, depth, and crispness. It is here the inker can display his personality and sense of aesthetics.

The inker's hand in things should be evident — subservient — but not dominated by the pencils. The inker should also have some idea of what the penciller is going for and some knowledge of how he has been inked before. Artistic respect has to come from both sides. Then, and only then, does the marriage of two distinct styles give us its best to enjoy, and this best reads like a roll call: Kirby and Sinnott, Adams and Palmer, Byrne and Austin, Miller and Janson . . .

figure 84

SUNDRA AND JIL

Inks by

Brian Bolland
Rudy Nebres
Kevin Nowlan
Jerry Ordway
Steve Rude
Mark Schultz
Dave Stevens

Brian Bolland

The first thing you need to know is that with the exception of the panel borders and a straight horizontal line in panel three for which I used a Rapidograph, everything was inked with a Winsor & Newton series 16 #3 sable-haired brush. I've never been able to work with a pen of any sort. Sometimes I scribble on texture with a Rapidograph because I have a vague idea that working with a pen ought to be quicker, but I usually go back to the brush and get the same effect just as easily and quickly — which, compared to most artists, is not very quick at all.

When I inked this page, the brush was behaving quite well, but often — and it's usually when the work's late already — I find that the tip of the brush has separated into two points of unequal length which gives me a line that changes thickness or splits without my being able to control it, and I'm constantly rotating the brush in my hand to align the two points. Eventually, I grind to a complete halt and throw the thing away. The best brush is one that's had a fair amount of use, is just a bit clogged up at the base of the bristles, but still comes to a good point.

I also ought to mention that I use Rotring drawing ink which I squeeze into one of those little containers with lids that 35mm film comes in. I top it up with a few drops of water. Often, when the inking isn't going very well, I pour the ink

away and fill the container afresh. That seems to do the trick.

I haven't done very much inking of other artists. I inked some of Dave Gibbons' *Dan Dare* pages many years ago, and I inked a Neal Adams *Crazyman* cover. That's it, I think. So, it's a great experience for me to ink an artist as good as Steve Rude. I ought to do it more often. You can learn a lot from it.

I believe that it's not the job of an inker to re-draw the work of the penciller. If someone was inking me, I'd expect him to reproduce in ink everything I'd drawn in pencil — or better still, everything I intended to draw — or even better, if I'd failed to get something right in pencil, he'd be able to pull it off in the ink. In other words, he'd have to be able to read my mind and be superhuman!

Having said that, I've taken one or two liberties with Steve's pencils, partly because I pencilled this all again on a light box before inking it so the original still exists somewhere unadulterated, and partly because this is a book about inking, and it would be dull if all the versions of this page looked exactly the same.

Panel one: I took a tracing of the right (our left) eye of the foreground face and flipped it so that the two eyes were symmetrical. I moved all of the background figure except for her right forearm a shade to the right (our right) in order to slightly elongate her upper right arm.

Panel two: On the light box, I somehow managed to lose the face of the seated figure and couldn't quite get it back.

Panel three: I mucked about quite a bit with the right arm of the seated figure, also her left hand and the joint at which her left leg joins her hip. I had trouble working out the picnic basket throughout the whole page. I added a handle here. I moved the left leg of the standing figure, and I'm afraid I didn't make a very good job of

her face. I think I'm going to need glasses soon.

Panel four: I moved the right leg of the standing figure and did something to the left hand and arm of the foreground figure.

I added some shadows here and there. I blacked in the sky throughout and the stream in panel three. I don't feel comfortable unless there's something of a balance between black and white. My earliest influences were artists like Eric Bradbury and Jesus Blasco who worked in British comics in the '60s and didn't have the benefit of color, but their expert use of black and line tone was all the "color" they needed. I also added in panel three a horizon line and a landscape and its reflection. Hey, I was out of control.

I enjoyed this quite a bit. I might *become* an inker! I look forward to seeing and reading the book. Best wishes.

P.S. Would your readers be interested to know that I'm left-handed?

"If someone was inking me,
I'd expect him to reproduce in ink
everything I'd drawn in pencil —
or better still, everything I intended
to draw. In other words, he'd have
to be able to read my mind and
be superhuman!"

Rudy Nebres

As a true believer in Good Anatomy, I approach my work with a particular eye on the the figure. I enjoy inking over pencils where the penciller has an eye for accurate anatomy. Anatomy need not be overly accurate but dynamic enough in its presentation to please the viewers' eyes. Steve's work has both these qualities.

The first thing I do is outline the pencils with a good, thin pen, usually a Pentel fountain pen. After the initial, "outline" inking is done, I use a brush — a Winsor & Newton series 7 #2 — for the various renderings and special effects. Clean pencils make the rendering much easier.

By the way, Steve is a good penciller.

Kevin Nowlan

with a #1 Rapidograph and a French curve. The bottle and lid were inked with a #0 and an ellipse template.

Next, I pencilled some shadows and inked them with the Raphael brush. Some of the additional details and textures in the background were inked with the quill pen.

Finally, I went back and added a few more shadows and thickened up some of the outlines.

I generally use these tools for most of my work:

- Hunt quill pen #102
- Raphael or Winsor & Newton sable brushes #3 or #4
- Rapidograph pens #0, #1, and #4
- Pelikan or Black Magic ink
- Pro White paint for corrections

First, let me get my apology out of the way. Steve Rude is one of the finest illustrators working today. His characters are wonderfully animated. They have natural gestures and eloquent expressions. He draws with such beautiful clarity . . . it's painful to watch a moron like me pick up a pen and destroy one of his pages.

My biggest frustration with this piece was my inability to preserve much of Steve's style. I'm a lousy mimic, so when I added the rendering and shadows, it started looking less and less like a Steve Rude page. I'd like to think I would have done a better job if I had been inking Steve's finished pencils instead of doing finishes over a layout . . . but I don't know.

Well, anyway, here's what I did. I like big, fat panel borders, so I began by ruling them with a #4 Rapidograph. Then, I inked all of the line work with a #102 Hunt quill pen. The long, curved stems and the picnic basket were inked

Jerry Ordway

Let me state right up front that I have mixed feelings about the results I achieved inking this page. Steve Rude is an excellent draftsman and storyteller, and I felt a bit intimidated treating this page as "layouts." My first instinct was to just ink what was there, adding line weights, etc., but as I looked at the results, I saw the need to drop some black areas into the page for contrast and depth. This is what a finisher is supposed to do, after all.

My favorite technique for deciding where black areas need to be spotted is to squint at the page from an arm's length. If nothing pops out at me, I start in on the piece with a Grumbacher #4 Sable Essence brush loaded with Pelikan drawing ink — the only brand I like. Since this page was inked onto two-ply Strathmore Bristol board using a light box, I had to be extra careful in checking my line weights. Light boxing always plays havoc with my eyes, and I sometimes ink too thick with my Hunt #102 crow-quill pen tip. Again, squinting is a good remedy for this!

My thoughts on inking in general all apply to this assignment. First, I've never liked inking unlettered pages because that's important information about the story that may help in my choices on rendering. In this case, I really had to stare at the page a while to figure out what I was looking at — are those splashes in panel three

supposed to be water, or flowers, or flowers squirting water? I don't know, but they must be solid, or that bird would have fallen in, right? Another problem that faced me on this page was that I hadn't inked Steve Rude before, and I never seem to find my rhythm on any job until I've inked four or five pages. Oh, well . . .

When I first started as an inker, I was pretty desperate to make anything I inked my own. I loved jobs that needed a lot of work, a lot of fixing, because I was trying to prove to my editor that I could handle a pencil! I wouldn't have wanted to ink a Steve Rude back then. I would have felt guilty trying to overpower the pencils. A few years into my career, I did get to do regular pencilling. After that, when I returned to inking, on *Crisis on Infinite Earths*, I had a different attitude. George Perez was the big "draw" there, so I attempted to restrain myself to just polishing up what he had put down! The same was true of my inking on *Fantastic Four* over John Byrne. His stuff was very complete, and he would indicate all kinds of surface textures on things, so I had fun making my pen lines bounce all over the place. I know he appreciated that I didn't ink every background object with the same texture.

Metal is shiny, rocks are grainy and rough, cloth is soft, etc. You have to be able to communicate these things in your inking. You also have to think, "Would a wall just be made up of chunks of rock, or would it be 2" x 4" lumber, plaster, insulation, electric wiring, plumbing pipe, and a lot of dust?" Think about what you're inking! Again, having a copy of the plot or script helps too.

If you are wanting to be a good inker, I can't stress how important it is for you to really be able to draw. It's not just tracing, and it's not all just technical proficiency. To be able to understand what a penciller puts down on the board, you have to speak the same language. The best inkers are all fine artists in their own right.

Good luck!

here. No two inkers' work will look alike. Feel free to add, subtract, or delete anything to help the overall finish of a page.

Steve Rude

Main tool used: Cosmos-Extra #4 brush

I was asked to ink two pages of my own work for this book. Both pages were inked on vellum — a thicker version of tracing paper — that was spray mounted over Xeroxes of my pencils. I used a Cosmos brush #4 for 95% of the work. A small, stiff pen nib filled in some detail areas.

All the figures, even the tiny ones, were done with a brush. Believe me, it's not as easy as it looks. Professionals and amateurs alike know that one misplaced line can change everything. Be prepared to white out what needs to be corrected.

Two completely different approaches were used to ink these pages. Here, on the Sundra page, the black areas were "spotted" first and outlines saved for last. On the Nexus page (see page 84), everything was outlined first and blacks filled in after. Both approaches produce different results.

The Sundra page is referred to as a "layout" page, where the page is either drawn tight or sketchy, and it's up to the inker to fill in where the black areas will go. By spotting the blacks first, I could decide if adding certain shadow areas would make the page read better and help the figures stand out more. Using this approach, an inker's abilities are really called into play, as you will see by the different examples provided

Mark Schultz

I should begin with a caveat: I seldom ink the pencils of anyone other than myself, so I'm not sure how much practical experience I can offer to those who wish to make a profession out of finishing other people's pencils. Inking Steve Rude's page for this book was a unique experience for me.

I have no preference in India inks since I slightly water my ink anyway to help it flow smoothly. The surface I draw on is Strathmore 500, two-ply, plate-finish, Bristol board. Two-ply is lightweight enough to allow transfers on a light table but heavy enough to stand up to a fair amount of re-working. The brush I use is an industry standard, the Winsor & Newton series 7, #2 although I'd probably use a #3 or #4 if they weren't so expensive.

I never got the hang of using a pen and don't use one except when an absolutely dead weight line is called for. In that rare case, I'll use a Hunt 102 or 107 crow-quill nib against a straight-edge. As an aside here, let me mention that while I sometimes make elaborate use of ellipse templates where needed when pencilling, I ink my circles and ovals freehand with a brush to try to keep the line vibrant.

For correcting ink mistakes, I use an electric eraser. I don't use the eraser strips labeled as for ink correction, however. They are far too abrasive and will eat up even the best paper. I use the pink eraser strips designated by the manufacturer as for pencil corrections. I like FaberCastell's #74. This eraser will, with patience, gently remove ink missteps with minimum damage to a good board like Strathmore 500.

I prefer the electric eraser over white-out — opaque, white watercolor — for correcting my mistakes because I hate trying to ink over the thick white-out surface. However, when white-out is required for negative effects like stars, or blades of grass against a dark background, I use Pro White, watered down a bit, like my ink.

Since I generally ink my own work, I'll write from that perspective. I try to work out all my drawing problems while pencilling. There are artists who are comfortable just roughly sketching in their designs with the pencil and then completing, or allowing someone else to complete, the bulk of the drawing with brush or pen, but I'm not one of them. Before I start inking, I want to feel confident I've got all my drafting and storytelling ducks in a row. When I'm inking, ideally, I want to be concerned with technique only: creating an attractive, visually exciting finish by the manipulation of ink with a brush. This, of course, requires meticulous and time-consuming pencilling, but that seems to be what I am temperamentally best suited for.

I realize that in the production-line system within which many comic books are assembled, it is often unrealistic because of deadline considerations to expect the penciller to provide completely realized pencils. In this case, the inker must make drawing decisions.

When I inked the Steve Rude page reproduced here, I had to make choices concerning the placement of blacks as Steve's pencils were totally linear. As I knew the finished piece was to be reproduced in black and white, I felt free to incorporate heavy areas of black to help create drama and contrast. If the page was to be reproduced

in color, I probably would have used much less black to allow the color more prominence. In any regard, I tried to work with Steve's pencils, to build on them and work in their spirit. The inker's stylistic tendencies should never overwhelm the penciller's.

If you treat it carefully, a good, round, sable brush will keep its point a long time though not as long as in the past. Brush quality, like paper and ink quality, is continually dropping, probably because there are fewer and fewer professionals buying these tools. When I've lost the point off a brush, I don't retire it; I put it on drybrush detail. Drybrush is a split-hair technique where the inker purposely forces the hairs of the brush to flatten and separate. This, combined with a minimum of ink loaded on the split hairs, allows for all sorts of unique line effects when dragged across the paper. Depending on how you force the hairs to split, you can create fuzzy, craggy, or vibrant line characteristics. It's not an exact science; it takes practice and patience to get comfortable with drybrush, but, for me anyway, the variety of effects you can achieve makes this technique worth the effort.

To finish an inked page, I'll often flesh it out with some dot screen. Screens can be especially helpful for pages that will be reproduced in black and white. The tonal variation they offer can help mitigate the starkness of unrelieved black and white. These are best used sparingly, though. Too many just clutter a page. For general purposes, I use the "sand" pattern. I like its organic quality.

Study, study, study the masters of ink technique: Goya, Tiepolo, Van Gogh, Hokusai, Coll, Dan Smith, Stoops, Sickles, Foster, Raymond, etc. Keep digging and discovering, and you'll never stop improving.

"I realize that in the production-line system within which many comic books are assembled, it is often unrealistic because of deadline considerations to expect the penciller to provide completely realized pencils. In this case, the inker must make drawing decisions."

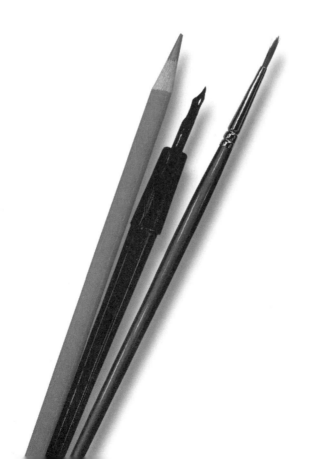

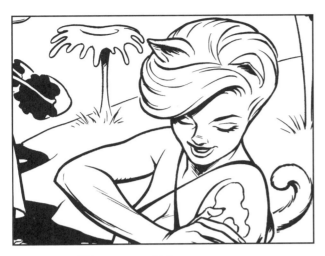

Dave Stevens

Although I really don't hire myself out as an inker, I have, on occasion, stepped in at a friend's request to help out with a job or two. I've enjoyed collaborating with quite a few of my peers and several of my elders on the odd cover, pinup page, or short story. So, I may not have the same perspective of someone who does this for a living, but . . .

For me, the process of inking basically comes down to choices. I think most good inkers operate by instinct. I know that when I look at a pencilled page, I look first for the strong areas — where the penciller really rose to the occasion and did his best to spell everything out, thereby making my job pure pleasure — and then for the weak spots — sketchy, loose areas that he obviously drew, *or didn't*, on autopilot, requiring me to step in and take up the slack. Then, I start to sort of "feel" my way through it with the brush, trying to strike a balance between line work and black areas.

Unfortunately, I've never been very good at "spotting blacks" in my own storytelling, so, as an inker, I'm not able to contribute as much as say, Kevin Nowlan, who is absolutely brilliant when it comes to dramatic lighting and rich blacks.

As far as breaking the rest of it down, it becomes a process of refinement: what to leave in, what to leave out, and what to add. Obviously,

I leave in all the artist's best efforts, clarifying detail if needed. I tend to leave out any unnecessary clutter, meaningless detail, or simple drawing mistakes. I add only what I think will help make the scene richer, or the characters more real, to the reader. anything more becomes selfish and inappropriate for the job. And it is the *penciller's* vision that we're embellishing.

Sometimes, I've been specifically *asked* to bring more to the table, to give a job my own "look," and in those cases, I've pulled out all the stops and hoped for the best. But in general, inking must *serve* the pencils rather than smother them. I think everyone included here would agree.

AFTERWORD

I can't end this book without mentioning some artists whose inking abilities I admire. The list below includes artists from both past and present. If it had been possible, I would have included their work in this book.

Dan Adkins	*Klaus Janson*
Alfredo Alcala	*Walt Kelly*
Murphy Anderson	*Steve Leialoha*
Hilary Barta	*Rick Magyar*
John Beatty	*Jerome Moore*
Brett Breeding	*Paul Neary*
Reed Crandall	*Art Nichols*
Jack Davis	*Bruce Patterson*
Hal Foster	*Alex Raymond*
Alex Garner	*Mike Royer*
Michael Golden	*John Severin*
Al Gordon	*Joe Sinnott*
Floyd Gottfredson	*Bob Smith*
Jaime Hernandez	*Bob Wiacek*
Dennis Janke	*Al Williamson*

The one man who, I think, did the best comic-book inking ever was *Frank Frazetta*. Even after all these years, no one has come close to touching his abilities.

I hope this book has been helpful to you and made inking less of a mystery. It would be nice if I never again had to hear those dreaded words: "Don't you just trace over the pencil lines?"

publisher • **Mike Richardson**
editor • **Lynn Adair**
manuscript doctor • **Anina Bennett**
book designers • **Brian Gogolin and Mark Cox**
photoshop designer • **Jimmy Johns**
hand model • **David Land**

THE ART OF COMIC-BOOK INKING™

Published by
Dark Horse Comics, Inc.
10956 SE Main Street
Milwaukie, OR 97222

First edition: October 1997
ISBN: 1-56971-258-1

4 6 8 10 9 7 5 3
Printed in Canada

NOW IT'S YOUR TURN.

*Remove the Bristol-board insert at the perforation
and practice your own inks on Steve Rude's pencils.
If you want to use this page as a sample,
refer to chapter XII PRACTICAL TIPS,
under Showing Samples.*